IMAGES
of America

SAN MATEO

SAN MATEO
THE FLORAL CITY

San Francisco's Nearest and Most Beautiful Suburban City

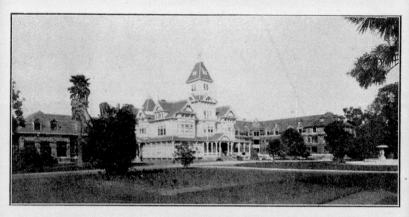

THE PENINSULA

Now in course of construction at a cost of $500,000 will open April 1st, 1908
accomodating 400 guests

San Mateo has reached that stage of development which nothing short of complet annihilation can now permanently check. The expansion of San Francisco, as inevitable as that of New York, must in the very nature of things be toward San Mateo, on the land side, unimpeded by intervening water. Just so surely as New York has, by degrees, spread into West-chester, so must San Francisco march into San Mateo with the teeming thousands which are to populate the new and greater city. With such a future, San Mateo becomes a point of wonderful opportunity, not alone to the suburban home seeker, but to those who recognize the value of realty investments as sources of future wealth. Just as up-town realty built up the Astor fortune in the Eastern metropolis, so will future Astors of this coast realize from investments in San Mateo and vicinity.

For any further information, address San Mateo Board of Trade or any of the following:

H. N. Royden, Real Estate
Peninsula Realty Company, Real Estate
Loveland & Shand, Real Estate
W. H. Cone, Real Estate
B. L. Grow Realty Co., Real Estate
E. M. Warn Lumber Co.
W. E. Tourtelotte, Contractor
Chas. N. Kirkbride, Attorney-at-Law
Clare-Metzgar Co., Furnishing Goods, Clothing
E. H. Alt, Shoe Store
Levy Bros., Merchants
San Mateo Bakery
T. Masterson, Hotel Wisnom
J. A. Foster, Electrical Engineer

Wisnom, Bonner Hardware Co.
Jennings Bros., Livery
A. L. Sanderson, Dentist
Sneider & Smith, Furniture Store
G. Palanca, Floral City Music Depot
C. M. Morse, Druggist
Peninsula Meat Co., Meat Market
San Mateo Planing Mill Co.
J. F. Killelea, Co., Painters and Decorators
Borges & Kenner, Cigars and Stationery
John F. Lee, Building Contractor
W. R. Spence, Pianos and Phonographs
C. W. McCraken, Confectioner
N. Van Kammen, Jeweler and Optician
H. G. Von OORSCHOT, Photo Studio

This advertisement, which appeared in *Sunset* magazine in 1907, extolled the amenities of San Mateo, dubbing it "The Floral City" for unknown reasons, a nickname that did not catch on. The picture is of the Alvinia Hayward estate, which became the ultra-swank Peninsula Hotel after its builder's 1904 death. The hotel faced Ninth Avenue at Laurel Avenue. The structure burned to the ground in 1920.

IMAGES
of America

SAN MATEO

Gregory N. Zompolis

ARCADIA
PUBLISHING

Published by Arcadia Publishing
Charleston, South Carolina

Printed in the United States of America

Library of Congress Catalog Card Number: 2004112271

For all general information contact Arcadia Publishing at:
Telephone 843-853-2070
Fax 843-853-0044
E-mail sales@arcadiapublishing.com
For customer service and orders:
Toll-Free 1-888-313-2665

Visit us on the Internet at www.arcadiapublishing.com

CONTENTS

Acknowledgments 6

Introduction 7

1. Commerce and Industry 9

2. Fire and Police 51

3. Famous Faces 59

4. Social Life 65

5. Homes and Families 89

6. Schools, Churches, and Hospitals 101

7. Views and Events 117

ACKNOWLEDGMENTS

I would like to offer major thanks to the following people for making this book possible: Editor John Poultney, Robert Adamson, Dorothy Funke, Ray Daba, Shig Takahashi, Richard Ryan, Jeff Barile of the San Mateo Fire Department, Michelle Licata, Suzy Wisnom Nelson, Helen Chalmers Hellmann, Ed Stephens, Dr. Carroll Gregory, Christine Kupczak of the Hillsdale Shopping Center, and the San Mateo Chamber of Commerce.

For those who shared their photographs and stories, I am forever grateful. I am especially thankful to Mary Ellen Coffey, "Auntie Nellie" (1856–1952), who saved everything and was a significant posthumous contributor to this book, and to my late mother, Muriel Coll Zompolis, for rescuing it all after Auntie Nellie died.

INTRODUCTION

San Mateo is not known to a lot of people despite the fact that it is a city of almost 100,000. When residents of San Mateo who are traveling are questioned as to where they are from and they reply "San Mateo, California," they're liable to get a blank stare in return. When they explain that it is a mere 18 miles south of San Francisco, some recognition begins to register. "Oh," said one young lady in Idaho, "is San Francisco near Los Angeles?" Geography notwithstanding, San Mateo has no reason to stand out. While it is a very nice city in a very nice climate, it has no special features or theme parks to make the average American know where it is on the map, and perhaps it is better that way. San Mateo is a place where "nice" has stayed "nice." The city's downtown and older suburbs like Hayward Park have never deteriorated as so many did during the 1950s when people moved ever farther away from urbanized areas into vast suburbs like the San Fernando Valley. In fact, rather than deteriorating, many areas of San Mateo have actually gotten better. The homes are more desirable and hence more expensive. New luxury developments now dot the landscape within a literal stone's throw of downtown.

The name "San Mateo" is Spanish for "St. Matthew." The founding de Anza party was deeply Catholic and claimed land for the Spanish crown, which was entwined with the Catholic Church. Oddly enough, the site was named in the spring of 1776 but St. Matthew's recognized feast day is not until September. No one knows exactly why the name was chosen considering the de Anza party camped on the banks of San Mateo Creek, just west of El Camino Real off Third Avenue on what is now a beautiful little street named Arroyo Court. In the Catholic Church, St. Matthew is the patron saint of accountants and tax collectors and is traditionally considered to be one of the writers of the gospels of the New Testament.

While it is not possible to capture the full history and spirit of a town in only a few hundred photographs, it is the author's hope that the reader will come away with a bit of the flavor of what life was like in the earlier days of San Mateo. This book is not a depiction of the lives of the rich land barons whose vast estates comprised much of what is now San Mateo, as their history has been exhaustively reported in other publications. Rather, this book is more a look at the common men and women and how they lived, where they lived, and where they shopped. Instead of pictures of lavish estates there are pictures of the interior of a commercial laundry and a drugstore, among many other common places. Not all life in the past was lived in the manor house, and I have attempted to document what life was like for the majority of the population.

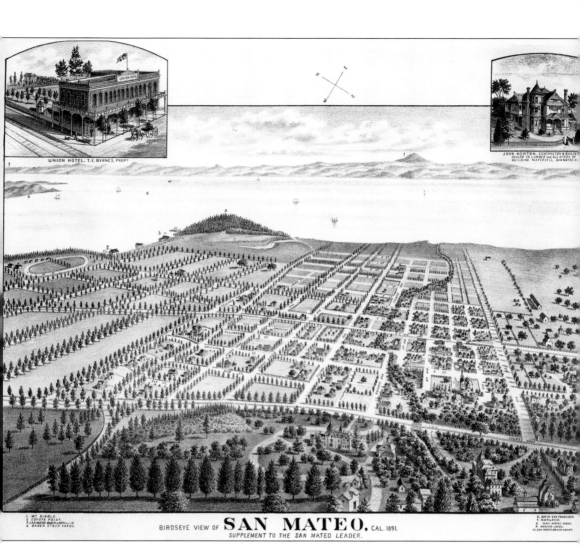

UNION HOTEL, T.E. BYRNES, PROP'R

JOHN MORTON, CONTRACTOR & BUILDER,
DEALER IN LUMBER and ALL KINDS OF
BUILDING MATERIALS, SAN MATEO C.

1 MT. DIABLO.
2 COYOTE POINT.
3 SAN MATEO BEACH & BATH HOUSE
4 BADEN STOCK YARDS.

BIRDSEYE VIEW OF **SAN MATEO,** CAL. 1891.
SUPPLEMENT TO THE SAN MATEO LEADER.

5 BAY OF SAN FRANCISCO.
6 OAKLAND.
7 SAN MATEO CREEK.
8 MERTON LANDS.
9 SAN MATEO BEACH & DAIRY

One

COMMERCE AND INDUSTRY

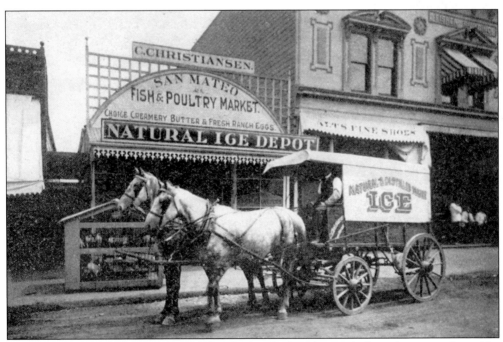

In 1904, fresh meat, poultry, and produce had to be bought regularly and consumed quickly, and the only way to extend their shelf life was to store them with ice. So it made sense for C. Christiansen to operate the Natural Ice Depot as well as the San Mateo Fish and Poultry Market. To be sure his customers received timely delivery of his quality pure ice, he employed the services of a horse-drawn wagon.

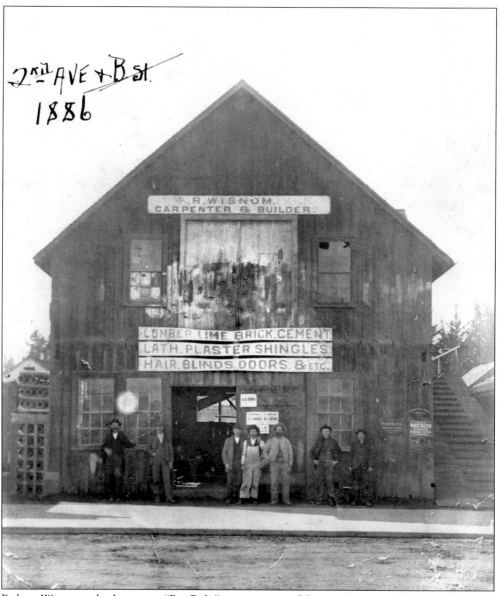

Robert Wisnom, also known as "Big Bob," was a native of County Antrim, Ireland, and arrived in San Mateo in 1863. A prolific builder, Wisnom is shown here (second man from the left) at the corner of Second Avenue and B Street in 1886. Many of his structures still stand.

The route from San Mateo over to Half Moon Bay and Pescadero was the Levy Brothers Stagecoach's first venture in the 1890s. It was a long, difficult ride over the hills following essentially the same road that exists today. Later, the brothers would open a department store in San Mateo.

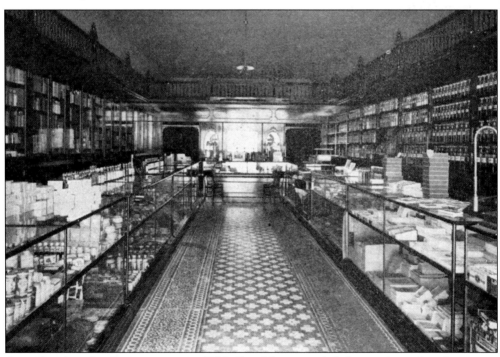

As with other developing towns in 1904, San Mateo needed the services of a pharmacist. The Baskette Drug Company filled the city's needs with distinction, providing a competent apothecary to compound physicians' prescriptions as well as carrying a full line of druggist's sundries. Baskette Drug Company was owned and operated by F.E. Baskette, a registered pharmacist and father of silent movie star Lena Basquette. He was also the first Grand Exalted Ruler of the San Mateo branch of the Elks Club when it was begun in 1908.

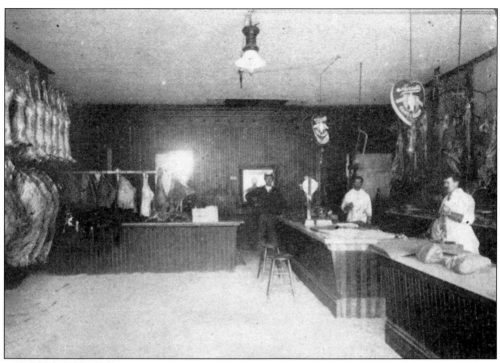

Brady & Shick's Palace Meat Market, shown here in 1904, offered a wide selection of steaks, roasts, ham, mutton, smoked meats, and lard. Their courteous service and quality meats at fair prices prompted increased trade until the business was destroyed by fire in 1913.

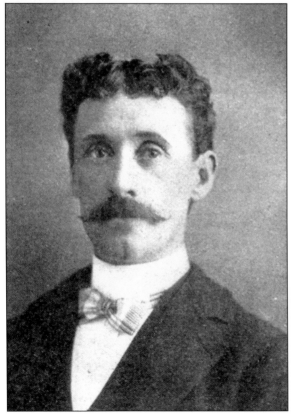

No rural community of 1904 was complete without its local supplier of wood, coal, hay, and grain. W.W. Casey served as that supplier in San Mateo.

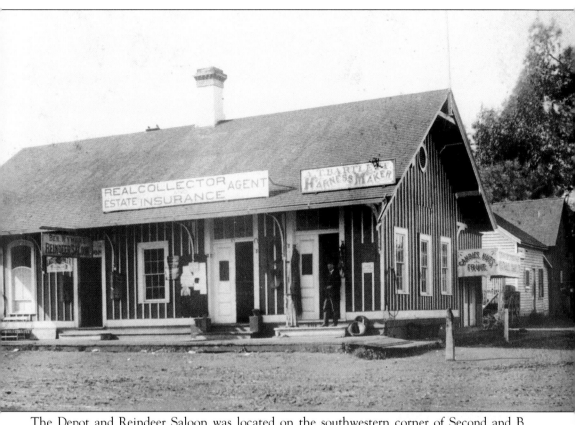

The Depot and Reindeer Saloon was located on the southwestern corner of Second and B Streets. The building, shown here *c.* 1880, once housed Barlett's Harness shop and eventually the Reindeer Saloon.

An excerpt from a 1904 ad was a fitting testimonial to the talents of blacksmith George E. Duffy:

Few of us have any idea to what extent the hoof of the horse is abused, and few have any conception of its requirements. Many people are of the opinion that any kind of a shoe will do, and that any kind of horseshoer can nail it on. Many a promising young horse has been virtually spoiled through poor shoeing, if shoeing it can be called. Many owners wonder why they have lame, footsore horses. To the sensible, experienced man this is all explained and the sensible man will never take a horse he values to be shod to the shop of an inexperienced horseshoer, and this leads us to call the attention of horse owners to the shop conducted by Geo. E. Duffy, who has had large experience and has given the foot of the horse a careful study. There is no blacksmith in this section who can surpass him.

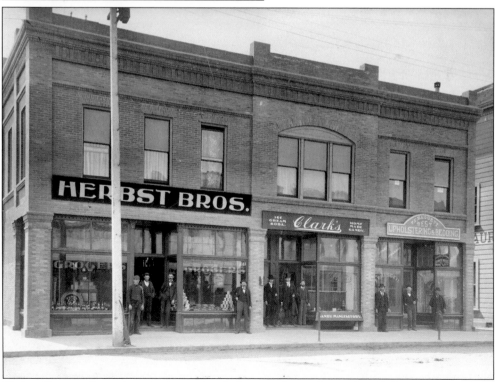

Herbst Grocers, shown here in this undated photograph, was located on B Street.

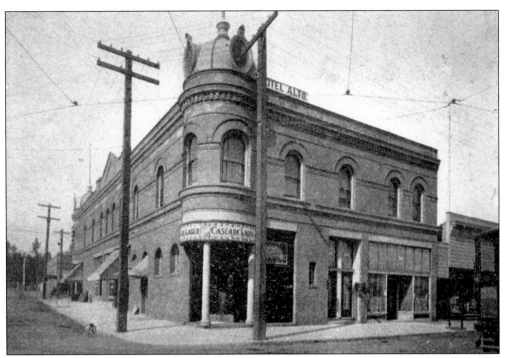

Local watering hole, the Magnolia Saloon, shown here c. 1904, was owned by Hugh McLaughlin and occupied one corner of the Coleman Building. The second story of the building housed the bedrooms of the Hotel Alto. Both businesses were damaged during the April 18, 1906 earthquake.

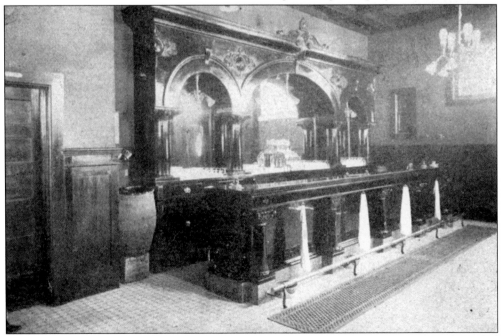

Patrons of Hugh McLaughlin's popular Magnolia Saloon's "sample room" were made to feel welcome by bartenders Con J. Talo and C.A. McKendrick. Then, as now, customers could get any drink mixed, discuss the weather or politics, and have a cigar.

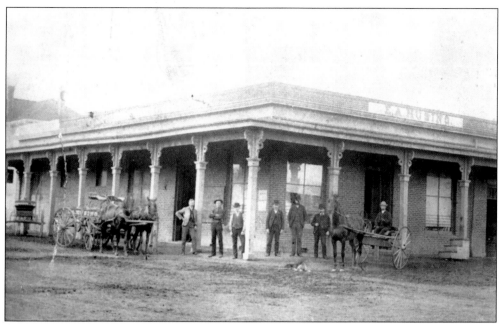

The first general store in San Mateo, Husing's was originally located along El Camino Real, but as businesses developed along the B Street corridor, Husing's moved to a more convenient site at the corner of B Street and Third Avenue, shown here around 1888. The store was operated by Gus Husing. Two other Husing brothers had similar businesses in other towns.

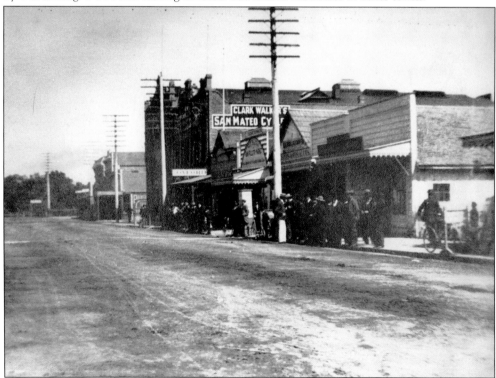

The Jennings Building was located at First Avenue and B Street.

George Zehender was an enterprising and progressive dealer of saddles, blankets, harnesses, and other horse furnishings who specialized in custom harnesses of the latest styles and finest materials, with satisfaction guaranteed. Zehender also was actively involved in the progress and development of his home town of San Mateo.

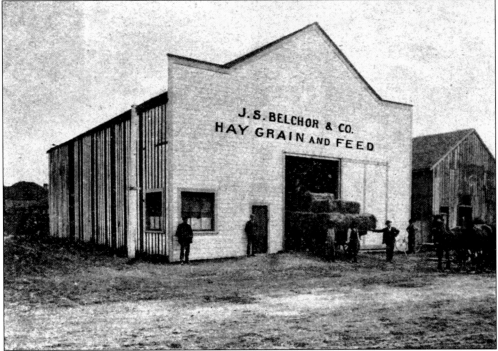

As a developing community surrounded by agricultural operations, San Mateo provided plenty of business for J.S. Belcher & Company, which sold hay, grain, and feed.

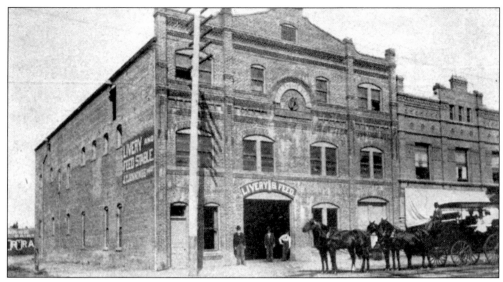

While horses were boarded and fed at the San Mateo Livery, shown here *c.* 1904, the business was significantly more than just a stable. Owner J.T. Jennings also maintained the best of driving stock, buggies, harness, carriages, and four-in-hands. Utilizing this location at First Avenue and B Street, several courteous and professional drivers offered patrons outings to many local sites of interest. Business was so good that Jennings was able to "modernize" in 1896 by adding an elevator to move carriages up to and down from the second floor. In the quake of 1906 the livery's roof collapsed but the rest of the structure survived.

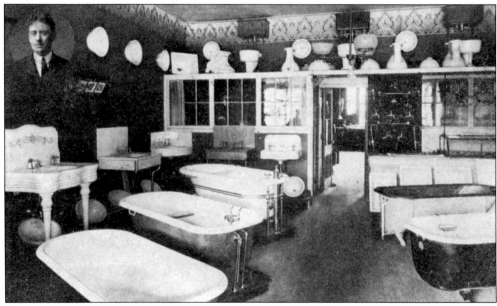

In 1904, from his large showroom at 17 B Street, plumber R.C. Smoot offered models of the latest kitchens and bathrooms as an authorized representative of the celebrated Standard Goods enamelware. As an authority on plumbing, gas fitting, steam and water heating, tinning, roofing, and galvanized ironwork, he closely supervised his skilled work crew to help ensure his reputation and customer satisfaction. Smoot also had the honor of being the first president of the San Mateo Association of Master Plumbers.

E. Buckman ran the local bakery, which specialized in breads, as well as a local hotel. As a baker and hotelier, he truly was an early entrepreneur.

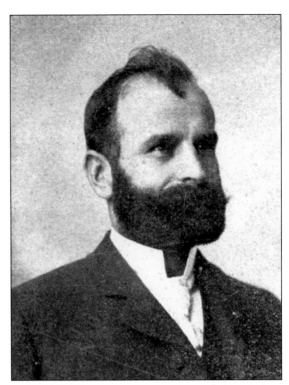

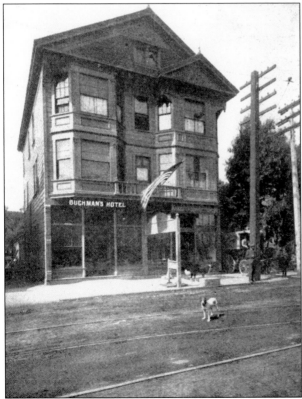

Buckman's Hotel, shown here in 1904, boasted moderate rates, well-ventilated rooms, and tiptop service. With everything first-class and the "landlord a gentleman," these accommodations in turn-of-the-century San Mateo were sought after by all who came to town.

As a contractor and builder in 1904 San Mateo, B.J. Duffy was responsible for the wood, brick, and stone construction and repair of many area dwellings. His interior work was also highly regarded. To help fill another need in this growing community, he even rented out materials "for the completion of houses for parties."

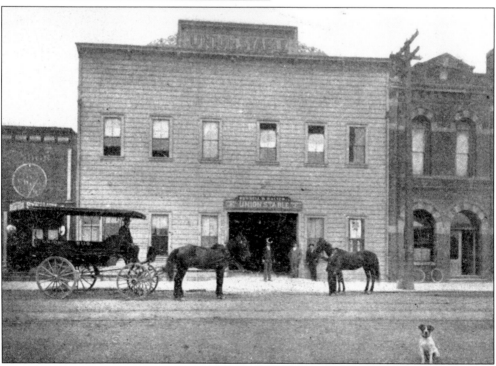

The Russell and Salter Union Livery Stable of 1904 boarded horses, maintained rolling stock of all kinds, and supplied drivers for functions such as funerals, weddings, parties, and sightseeing.

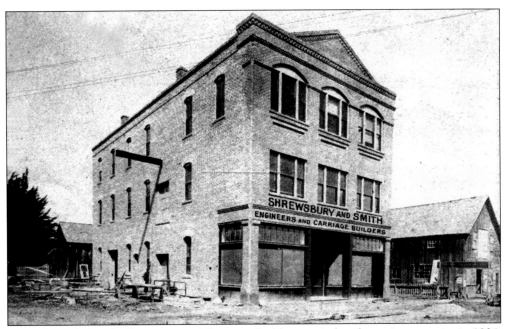

Shrewsbury & Smith, Engineers and Carriage Builders, a vital and growing concern in 1904, was all but destroyed by the earthquake on April 18, 1906. By April 23 what structure remained after the quake had been mostly torn down by its owner, thus negating the need for the newly organized building inspection commission to condemn it.

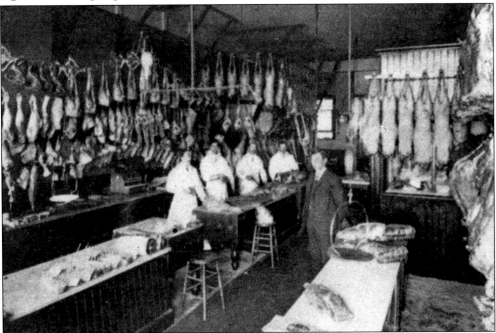

This picture of the San Mateo Meat Market in 1904 shows that owners Coleman and Schneider carried a full line of the choicest roasts, steaks, chops, hams, bacon, and smoked meats of all kinds. The market was reputed to be the leader in both quality and price and regularly circulated a delivery wagon through the city to accommodate its many patrons.

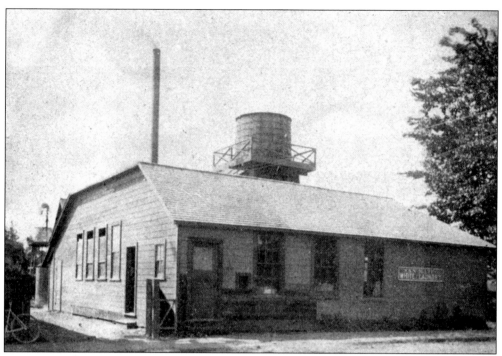

San Mateo Laundry manager J.E. Riley saw to it that all fabrics, from the finest lace curtains to household napkins, received prompt first-class service with free delivery of local items. The laundry itself was deemed to be first class, a fact of which city residents in 1904 were proud.

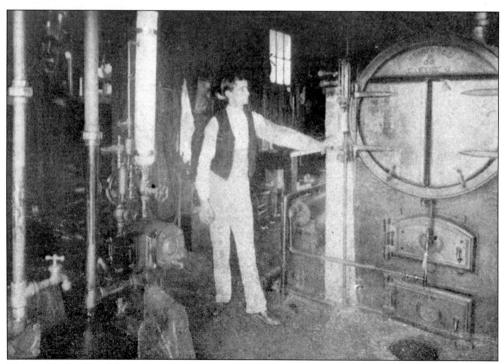

Pictured is the San Mateo Laundry's interior.

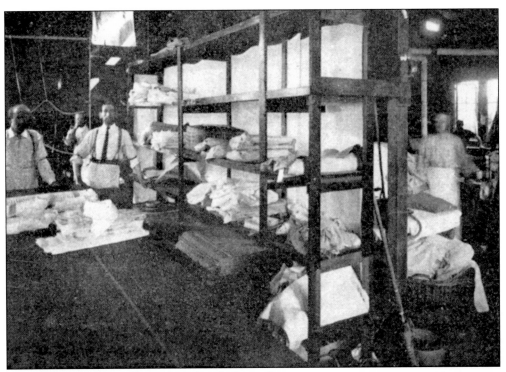

San Mateo Laundry employees pose beside the racks.

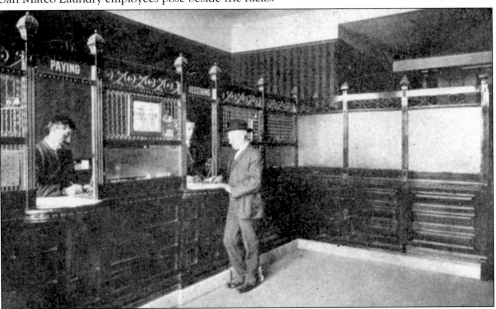

The San Mateo Bank, established around 1894, served the banking needs of local businesses and individuals. In addition to its courteous and obliging staff, the bank was operated by such notable officers as James J. Fagan, president; Robert Wisnom, vice-president; and A.P. Giannini, secretary. Giannini later founded the Bank of Italy, which became the Bank of America. The San Mateo Bank's assets in 1904 were $228,054.81. Put in the perspective of 2004 dollars, this is a pretty grand sum.

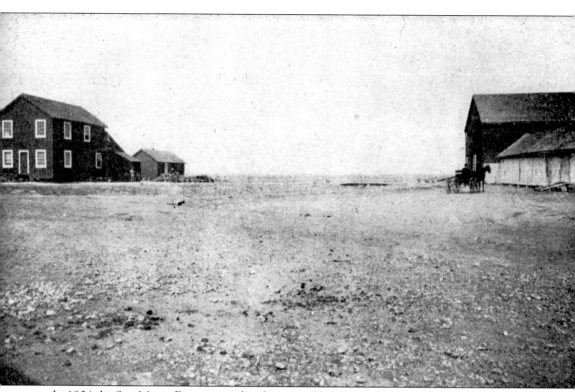

In 1904 the San Mateo Dairy, owned and managed by W.P.A. Breuer, was one of the largest in San Mateo County with 250 head of cattle. It not only delivered dairy products to San Mateans, but also shipped large quantities of milk to San Francisco.

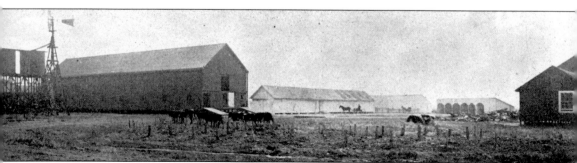

This is a panoramic view of San Mateo Dairy.

Robert James Wisnom, founder of Wisnom's Hardware, is shown here at around 20 years of age.

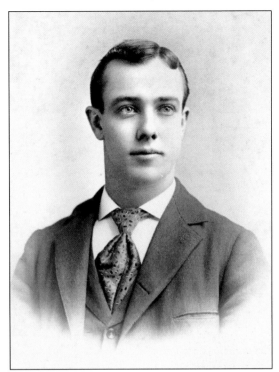

Robert James Wisnom, the son of "Big Bob" Wisnom, founded Wisnom's Hardware in 1905. Shown here in 1910, the business continues to this day and is operated by the fourth generation of the Wisnom family. Wisnom's once sold Dodge automobiles and appliances such as refrigerators; today it is the place to go for hardware, tools, housewares, gifts, fireplace accessories, barbecue grills, and pet food.

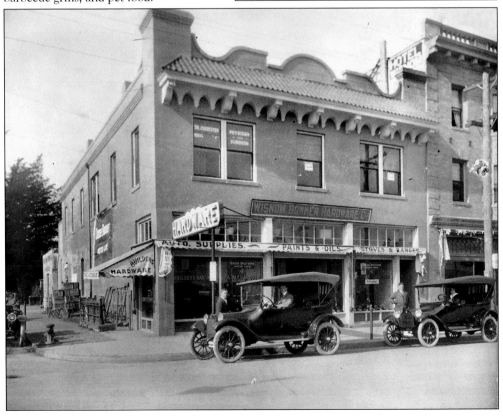

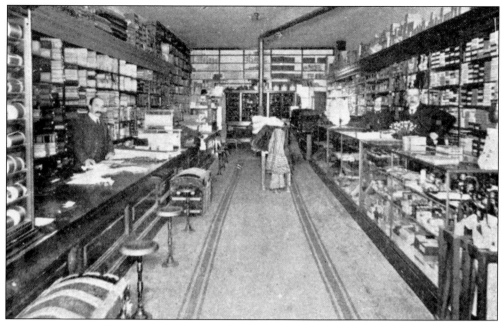

Established in 1872, Levy Brothers stocked everything a household might need, including foodstuffs. Shown here in 1904, the store eventually dropped other items from its inventory until it specialized only in clothing. In the early 1930s the Levys built a Tudor-style store on Third Avenue and, after outgrowing that one in the 1950s, built a Moderne-style store on Fourth and Ellsworth Avenues, now the site of Draeger's Market. In the early 1980s Levy Brothers moved once again to occupy the former Joseph Magnin store at the corner of Fourth Avenue and San Mateo Drive. Just a few years later, the store went out of business, a true blow for the numerous loyal patrons who had shopped there over the years, leading one woman to remark, "Now where will I buy my clothes?"

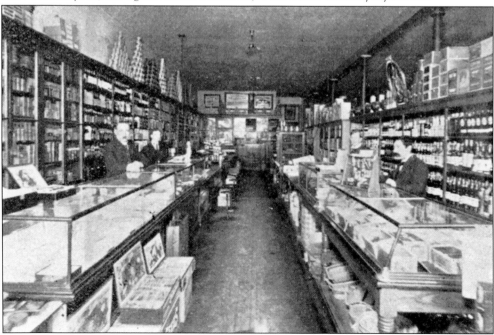

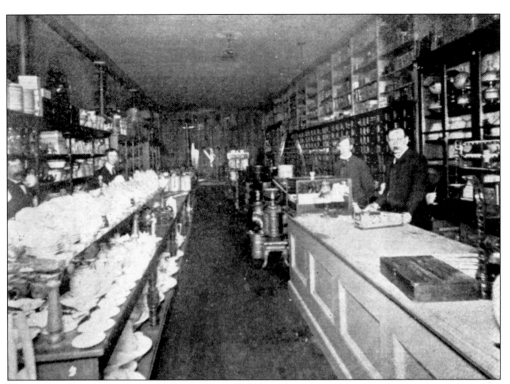

This is another view of the interior of Levy Brothers.

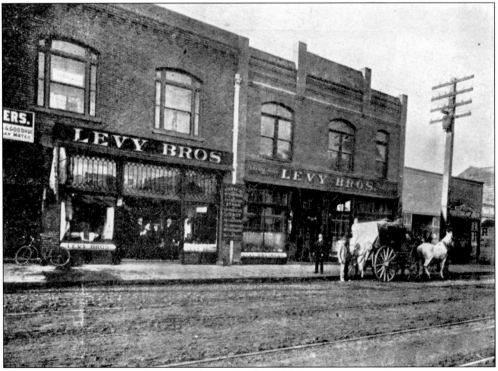

This exterior view of Levy Brothers was captured in 1904.

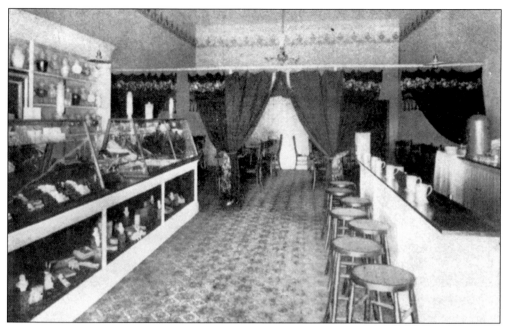

In 1904 the C.W. McCracken Candy and Ice Cream Parlor was the popular destination of all children and adults seeking to satisfy their sweet tooth. McCracken supervised the creation of the finest chocolates, glacé fruits, bonbons, caramels, and candies of all kinds. Refreshing sodas, fancy drinks, ice cream, and water ices could also be purchased.

Filming of Picture on Griffith Avenue Draws Large Crowd

First exteriors of "The Chalk Mark," a drama being filmed at the Peninsula Studios, San Mateo, are being taken today at 210 Griffith avenue, the throngs of movie and camera men attracting numbers of spectators passing along the street.

More than twelve carriages of the vintage of 1880 were gathered about the site, lending "atmosphere" to the scenes which deal with the early portion of the romance enacted in a small American city of the early 80's, it was explained by Frank Woods, head of the producing concern. Lighting for the exteriors is directed by Danny Rogers, San Mateo, chief electrician at the studios.

Costumes worn by Miss Marguerite Snow, leading lady, and Ramsey Wallace, playing the principal male role, were those of a generation ago, the Griffith avenue cottage being selected

The site at 210 Griffith Avenue (now San Mateo Drive) was the outdoor location for *The Chalk Mark*, a film made by the Peninsula Studios and shot by Frank Woods Productions around 1908. Starring Marguerite Snow and Ramsey Wallace, the film was wholly shot in San Mateo and depicts small-town life in the 1880s.

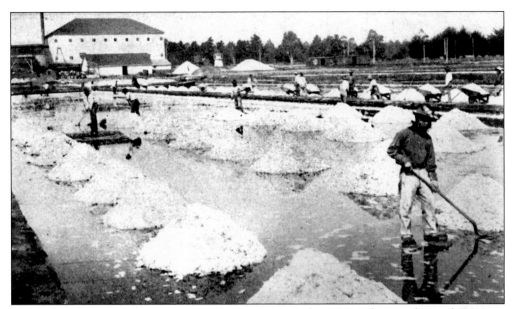

The Leslie Salt Refining Company got its start in 1903 when C.E. Whitney obtained 200 acres of San Francisco Bay marshland and built his plant at what is presently the area of Sixteenth and Leslie Avenues. The processing plant and evaporation ponds, which relied on the heat of the sun to produce crude salt from sea water, provided employment to many San Mateo residents. In 1907 the company was merged with other salt companies of the San Francisco Bay Area to form the Leslie Salt Company. Subsequent innovations in processing and packaging created a product that would be familiar to today's consumers.

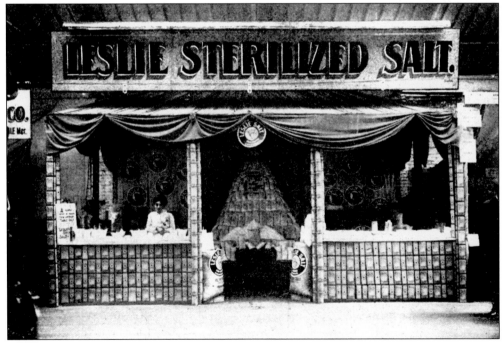

The display of Leslie Sterilized Salt won wide acclaim and garnered much attention when it appeared at food exhibitions in the early days of the Leslie Salt Refining Company.

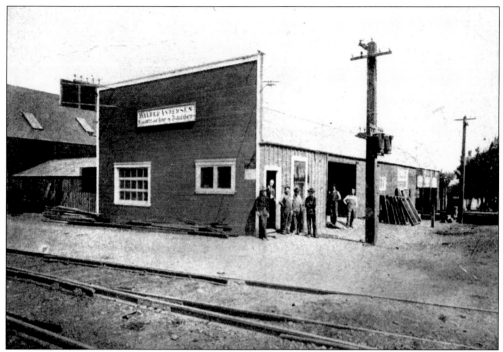

In addition to sawing, milling, and planing, the Walter Andersen Planing Mill, shown here *c.* 1904, was also headquarters for Andersen's building, design, and construction operations. Established in 1898, the company quickly gained a reputation for constructing fine residential and commercial buildings of wood, brick, or stone.

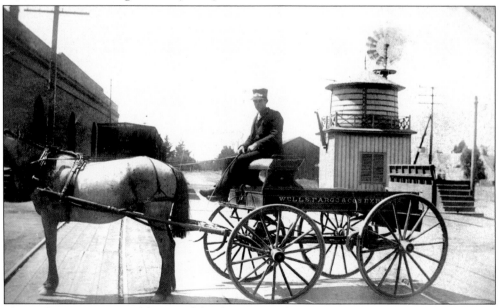

Shown here are J.M. Peckham and his horse Strawberry. Peckham eventually entered the moving business. According to the notation on the back of this undated photo, Strawberry was a "local character." Unfortunately, the horse's face isn't seen in this photo. Maybe that's his way of clowning around.

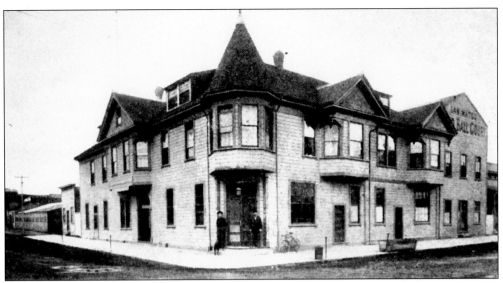

The Hotel Vendome, shown here *c.* 1904, was located at Second Avenue and C Street (now Claremont Avenue). Opened in 1896, it featured 50 elegantly furnished sleeping apartments, bathrooms, a "sample room" (for beer, wine, and spirits), a handball court, a ballroom, a dining room, and more. Bart Sheehan, the proprietor, saw to it that his establishment served the choicest liquors and cigars, and offered unsurpassed cuisine. As with many other business owners of the day, Sheehan could always be counted on to support public improvements for the benefit of his home city. The hotel remains standing today.

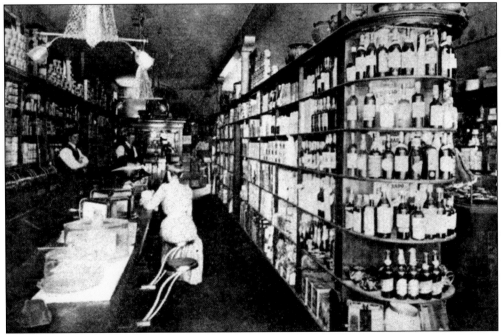

J.M. Early, Grocer, a leader of the business community in 1904, prided itself in stocking a wide variety of staple and fancy groceries. In addition, it served as the headquarters for crockery, queensware, and white graniteware in dinner, tea, and chamber sets. The building later sustained repairable damage in the 1906 earthquake.

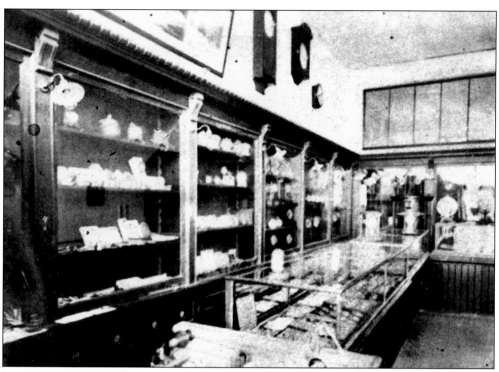

Like modern-day jewelry stores, C.L. Dresbach Jewelry in 1904 handled a wide variety of rings, pins, studs, silverware, clocks, watches, and a large assortment of diamonds. Particular attention was also paid to the repair of fine watches and jewelry.

A.C. Cooper was not only a skilled and knowledgeable tradesman, he was a merchant as well, selling a full line of electrical goods. Utilizing his technical and practical experience he gave special attention to construction work, electric lights, telephones, power circuits, house wiring, and burglar alarms. These accomplishments in the science of electricity would have amazed the forefathers of 1904 San Mateo. However, even at the time, many people still did not trust electricity, considering it a potential health hazard. Many homes were still built with gas lighting fixtures until the 1910s.

W.D. Cogley operated a leading, plumbing, and sheet metal establishment in 1904 carrying a full line of plumbing fixtures, bathtubs, water closets, sinks, pumps, windmills, and other miscellaneous plumbing accessories. He also contracted to manufacture water tanks and specialty sheet metal products. In addition to selling and installing the above items, Cogley took an active interest in the progress and advancement of the city.

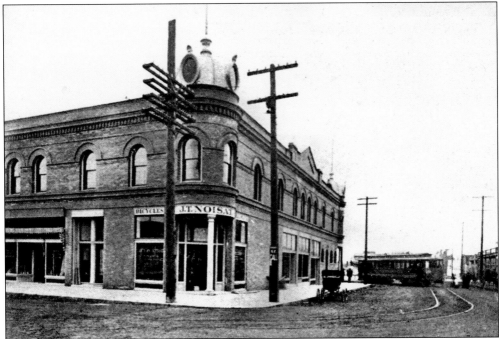

The mammoth Coleman Building, shown here c. 1904, leased space to many businesses, among them the Magnolia Saloon, Hotel Alto, and J.T. Noisat Bicycles and Sporting Goods. The latter was also likely the headquarters of talented photographer P.L. Noisat, whose work included outdoor, interior, and commercial photographs, many of which were included in a souvenir publication used as one of the sources for this book. The Coleman Building sustained repairable damage in the 1906 earthquake.

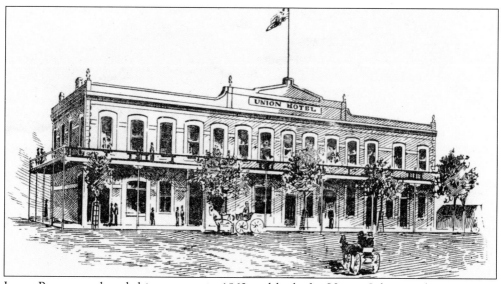

James Byrnes purchased this property in 1862 and built the Union Saloon with partner J.P. Ames. Later the business was expanded by Byrnes alone to include a barbershop, livery stable, rooming house, and a grain processing treadmill. By 1904 the site had been developed into the Union Hotel, which came to be well respected for its elegant furnishings, comfortable accommodations, excellent dining, and prompt, courteous service. The hotel sustained damage in the 1906 earthquake but managed to stay in business until at least Prohibition when part of its operation, the speakeasy, was raided and shut down by local law enforcement officials.

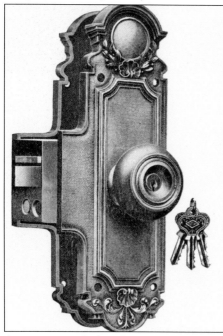
At one point, Robert James Wisnom entered into a partnership with a man named Bonner to establish Wisnom-Bonner Hardware. Then he bought out Bonner and continued the business on his own. This 1911 ad features a fine engraving of a doorknob and lockset available from the manufacturer.

Many of the early photographs used in this book are the work of commercial photographer J.T. Noisat. It is only right that his ad be shown here and he be given credit for a fine collection of work.

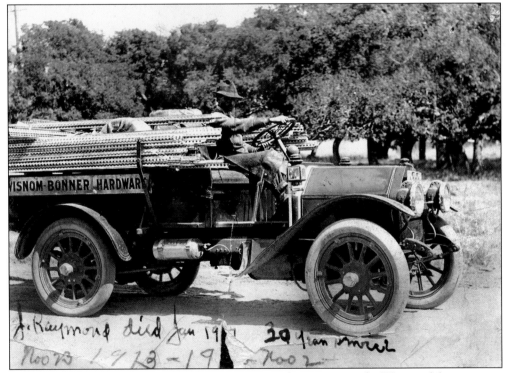

J. Raymond, who worked for 30 years for Wisnom's Hardware, poses in the Wisnom delivery wagon around 1917. It is still not unusual for Wisnom's to have extremely long-term employees.

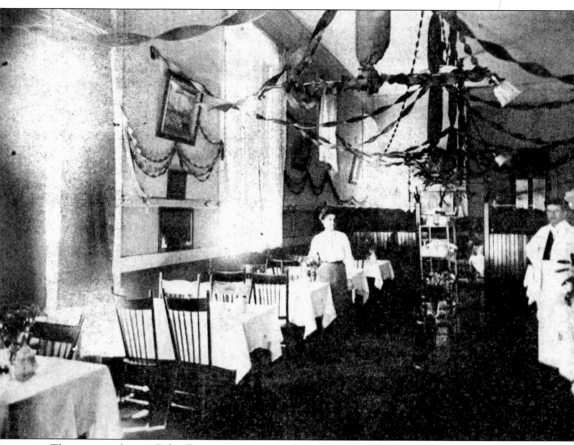

The neat and cozy Palm Restaurant, operated by Mrs. G.R. Maggi, served "regular dinner" (lunch) from 11:30 to 1:30, and short orders at all hours. This 1904 establishment served first-class home-style meals, including "tempting substantials and all the delicacies of the season," and it was considered a model establishment by local patrons and visitors alike.

FREDERICK SMITH FURNITURE CO.

FURNITURE, CARPETS, RUGS, PORTIERES, LACE CURTAINS
WINDOW SHADES, LINOLEUM

300 B Street, Corner Third Avenue

SOLD TO Mr.Jos.F.Call,

 11th Ave. San Mateo,Cal. SAN MATEO, CAL.

Sept.7,12

Qty	Item	Price	Amount	Total
1	Unfinished Round Table		4.50	
1	4/4 White Bolster		1.50	
15	yds. Linoleum Laying	.10	1.50	
2	C.S.Chairs in White	2.75	5.50	
1	76" Kirsch Rod		.50	
5	40" " "	.25	1.25	
3	28" " "	.35	1.05	
14	ft 3/8 Fl.Rod		1.00	
2	pr. Goose Neck Brackets		.50	
2	Center Supports		.05	
1	6ft Vudor Shade		3.50	
1	8ft " "		5.00	25.85
1	#543 Mhg. Dresser		25.50	
1	132 F.O.Rocker		14.00	
1	132 F.O.Chairs		14.00	
1	0365 F.O.Davenport with three cushions		50.00	
1	1001 F.O.Library Table		25.00	
1	817 Cr.Iron Bed		18.00	
1	4/4 Peerless Spring		4.00	
1	4/4 Hair Mattress silver Grey		18.00	
1	04251 F.O.54"-8ft.Dg.Table		35.00	
6	4632 F.O.Dg.Chairs Lea.		24.00	
1	Steel Couch		5.00	
1	Cotton Pad to fit		3.50	
1	121 Mhg.Rocker		4.25	
1	120 " Chair		4.00	248.25
				274.10
	Less Discount			15.00
				259.10
July 18th	Credit by Cash			5.00
	Net Balance			254.10

Frederick Smith Furniture was located on the site of Husing's store at the southwest corner of Third and B Streets. This 1912 invoice shows that a houseful of new furniture could be purchased for $250. Almost all the furniture described was the latest style of Mission oak ("F.O." for "Finished Oak") with the most expensive piece being the "davenport" at $50. The furniture was bought by Mr. and Mrs. J.F. Coll for their new Hayward Park bungalow, which did not even have a street number assigned to it yet, as evidenced in the address line.

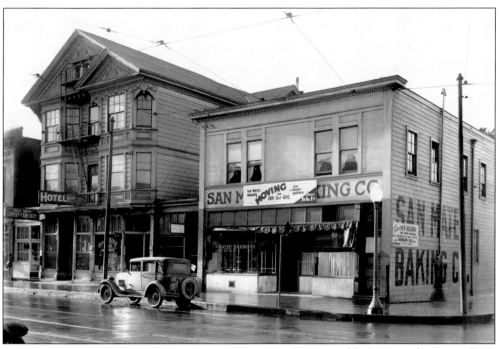

In this view of B Street in the 1920s, E. Buckman's San Mateo Baking Company announces—by way of the banner hung on the building—that it is moving. Buckman's hotel can be seen next door.

40

SAVINGS ACCOUNT

WITH

Bank of Italy

NATIONAL TRUST & SAVINGS ASSOCIATION

AT

SAN MATEO BRANCH
SAN MATEO, CAL.

NO.

CAPITAL	37½ MILLION DOLLARS
SURPLUS & PROFITS	25 MILLION DOLLARS
RESOURCES	700 MILLION DOLLARS

The Bank of Italy, founded by San Mateo resident A.P. Giannini, later became the Bank of America, the world's largest bank. This Bank of Italy San Mateo branch passbook dates from 1929.

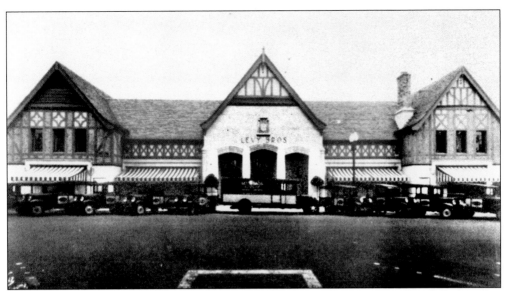

The Levy Brothers store on the north side of Third Avenue between El Camino Real and San Mateo Drive was built around 1932 in the Tudor style. It featured a mezzanine that surrounded the store's main floor. Today it houses an antique collective.

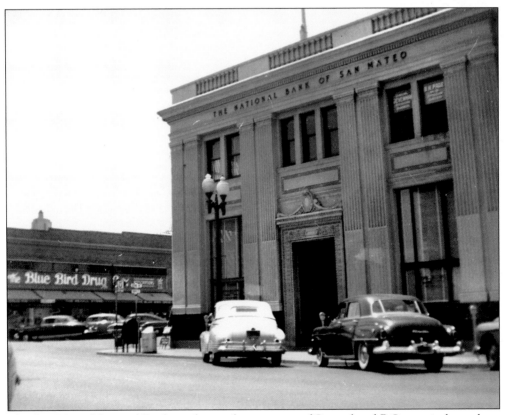

The San Mateo National Bank on the northeast corner of Second and B Streets is shown here around 1946.

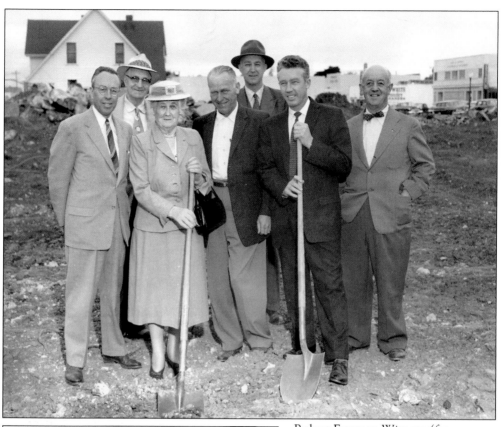

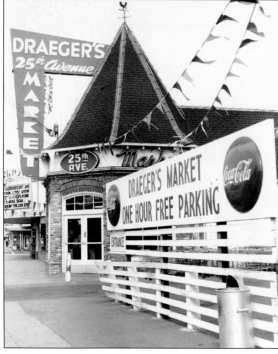

Robert Freeman Wisnom (far right) and Jenny Wisnom Elfving participate in the groundbreaking for Rakestraw's Market in the 1950s. The man in the hat in the center is Jenny's son Carl Elfving Jr. The others are unidentified. Rakestraw's was located between Ellsworth Avenue and B Street at Baldwin Avenue and is now Trag's Market.

This photograph of Draeger's Market on Twenty-fifth Avenue was taken in the 1950s.

David D. Bohannon poses with Beniamino "Benny" Bufano at the Hillsdale Shopping Center in 1955. Bufano's sleek animal sculptures were designed and hand-finished exclusively for Hillsdale Shopping Center, which was developed by Bohannon. Although "The Mall" as many locals call it, has been enclosed and renovated, it is still as chic as the day it opened. The famous Bufano sculptures continue to be the only art featured at the center. In 2004, Hillsdale celebrated its 50th anniversary. Still owned by the Bohannon family, the center has remained the premiere place to shop on the peninsula.

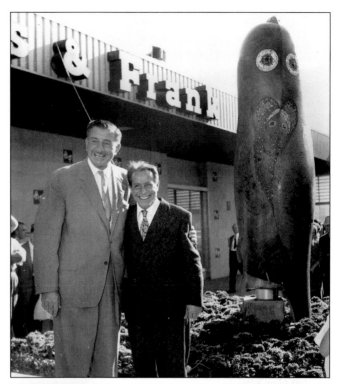

In 1953, a Macy's store was added to the Hillsdale Shopping Center. Having made construction history by being entirely built in only 11 months, it further expanded by adding a third story in 1962.

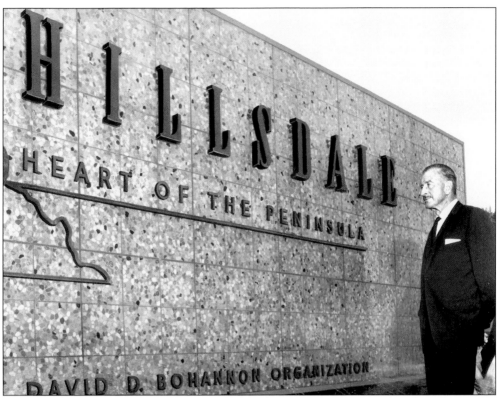

David D. Bohannon stands in front of the Hillsdale Shopping Center sign in this photo from 1955.

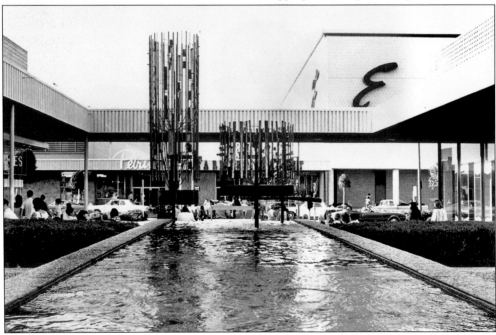

This 1954 view of Hillsdale Shopping Center looks north across Thirty-first Avenue toward the Emporium.

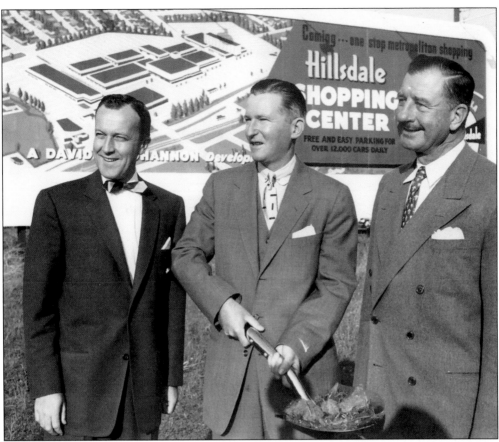

David Bohannon (right) attends the groundbreaking for Hillsdale Shopping Center with two unidentified men.

David D. Bohannon was the developer of the popular Hillsdale Shopping Center.

Situated on the southwest corner of Fourth Street and San Mateo Drive, "JM's" (as the Joseph Magnin store was called), featured the latest in upscale fashions. It catered mostly to young women, but also included a men's department and a children's department on the lower level, which could be reached by a huge, curving wooden slide. The store also featured giftware, as seen in this 1968 picture, that was made exclusively for the company. Joseph Magnin was part of a small chain based in San Francisco and whatever was considered the latest and hippest could be found there. The store's Christmas boxes were legendary, being designed by local artist Marget Larsen, who was JM's art director for over 20 years. The boxes had a different theme each year and people would buy something from the store just to get the box. The entire chain, founded by Cyril Magnin, went out of business in the mid-1980s.

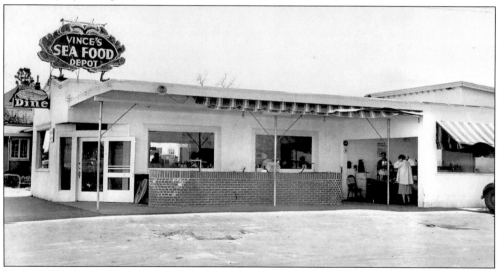

Undeniably the best seafood and Italian restaurant in the area, Vince's Sea Food Depot and Restaurant, shown here in the 1950s, was an institution, situated on the west side of El Camino Real opposite Fifteenth Avenue. Started by Vince Licata and later run by his sons, both enterprises were thriving businesses. The fish market was located on the north side of the property with the restaurant across the parking lot. No longer in existence, the site is now an office building.

HIPPO HAMBURGERS

San Francisco • San Mateo • Menlo Park

SAN MATEO – El Camino at 12th Ave.

57 VARIETIES OF THE HAMBURGER FROM THE CANNIBALBURGER (RAW) TO THE TAHITIANBURGER (EXOTIC). USE THIS COUPON WHEN YOU PURCHASE ONE OF OUR 57 VARIETIES OF "THE HAMBURGER" AND RECEIVE A COMPARABLE HAMBURGER FREE FOR YOUR GUEST. COUPON GOOD THRU TUESDAY, JANUARY 31ST, 1967.

Contrary to its name, Hippo Hamburgers served only beef burgers. No hippo meat or any other exotic meat was ever served there, although the Tahitianburger featured ti leaves, bananas, pineapple, and water chestnuts.

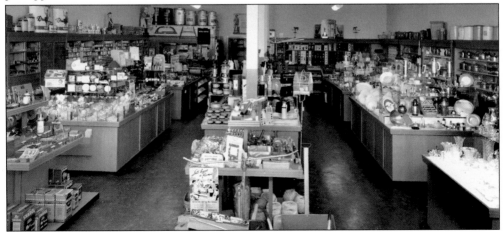

This interior view of Wisnom's Hardware was taken in 1956 at the store's B Street location. Wisnom's had everything a household could want. Everyone shopped there and over the years celebrities stood in line with everyone else to purchase the necessities of life. Bing Crosby was a regular customer and in the late 1970s, kidnapped heiress Patty Hearst and her guards were seen in the store.

RECEIVED FROM

DATE _Aug. 12/1935_

NAME _Mrs. Ella. T. Chalmers._

ADDRESS _Fr/ G. E. Refrigerator._

AMOUNT _200.33_

Wisnom Hardware Co.

TOTAL. _200.33_

PER _S_

For a time, Wisnom's sold appliances, and Mrs. Ella T. Chalmers purchased a General Electric refrigerator in 1935 for the then enormous sum of $200.33. Wisnom's keeps a similar model with the round motor on the top for display purposes. A 1941 model purchased from Wisnom's is still working perfectly and is used as an extra refrigerator in the Funke home in Aragon.

Commemorating a "Century of Service," this special stamp appeared on all Levy Brothers correspondence in 1972.

This Levy Brothers bill dates from 1972.

Receipts were still written by hand in 1972, and authorization took place by putting the request in a metal cylinder and sending it to the credit department on the second floor by way of a pneumatic tube.

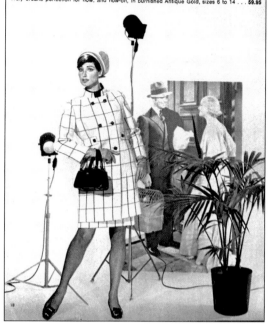

Roos Atkins was an upscale clothing store located on the south side of Fourth Avenue near El Camino Real that featured the latest in fashions for both men and women. The store was built with an unusual split-level design so that passersby could see into the lower level from the street. Roos Atkins was a San Francisco–based chain that has since closed. This ad is from the late 1960s.

Opened in 1970, the Royal Coach Motor Hotel was an ersatz version of a medieval hotel. Located at the end of Concar Drive facing the Bayshore (101) Freeway, it is now the Marriott. This ad ran in 1971.

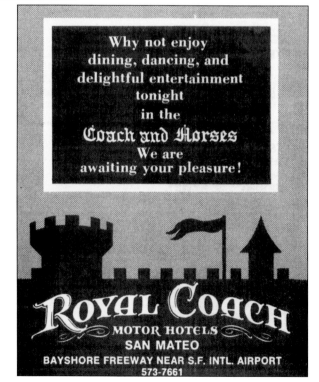

One of the finer local restaurants, the York was located on Fifth Avenue facing Ellsworth Avenue. This ad ran in 1971, several years before the restaurant ceased operations in 1975 when the entire block was torn down so the luxury condominium complex, originally called the Grosvenor, (now the Gramercy), could be built. The York's signature dish was real turtle soup.

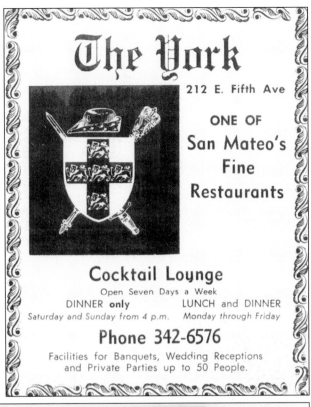

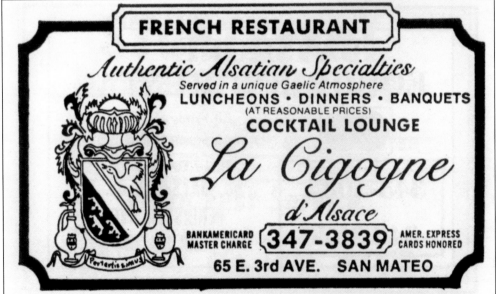

This 1971 advertisement was for La Cignone d'Alsace, one of San Mateo's fanciest and most expensive restaurants in the 1960s. La Cigogne served Alsatian (a region of France) specialties. It was located on Third Avenue's north side near El Camino Real. Leaded stained-glass windows gave it an upscale European atmosphere. It was truly one of those "special occasion" restaurants.

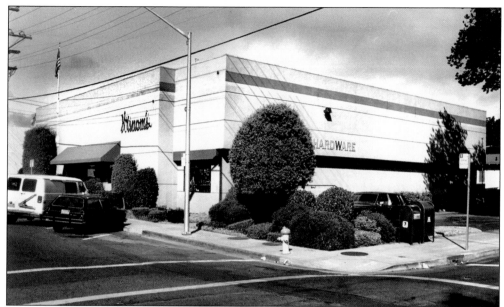

Wisnom's Hardware moved to this location at First Avenue and Delaware Streets in 1982. They are still in the same location today and remain a town favorite. One of San Mateo's oldest businesses, its stock extends beyond hardware to include all sorts of housewares and fine gifts as well as an extensive barbecue and fireplace department. It is not unusual to see major sports figures and local television personalities shopping here.

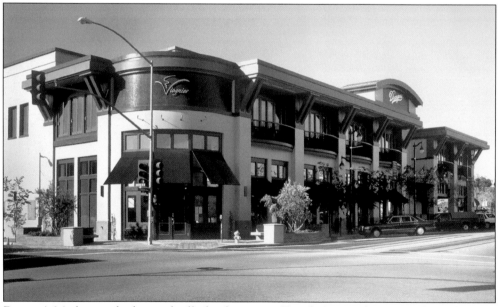

Draeger's Market was built specifically for this site on Fourth Avenue between Ellsworth and B Streets in 1997. Draeger's is perhaps the most upscale grocery store imaginable and truly an asset to downtown San Mateo. It has built a reputation for carrying a diverse and extensive line of fine food items, both domestic and imported. The upstairs boasts a cooking school, a housewares department featuring fine china and cookware, and a five-star restaurant, Viognier. It is owned and operated by the local Draeger family.

Two

FIRE AND POLICE

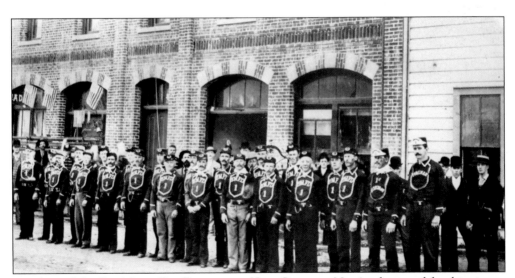

Members of the San Mateo Fire Department Hose Company No. 1, who posed for this picture on July 4, 1890, included Foreman Thomas Coleman, Assistant Foreman Thomas Flaherty, Assistant Foreman Joe Culbert, Mike Keegan, Charly Swansan, Jess Casey, Jack Nelson, E.H. Alt, Mike Howard, Bob McLean, W. Cummings, Jack Ward, Con Hermann, Fred Schular, Jack Leavy, Walter Jennings, Morris Powers, Johny Wisnom, Berdie Price, Charley Louie, Tony Hahihan, C. Wheeler, and George A. Bartlett.

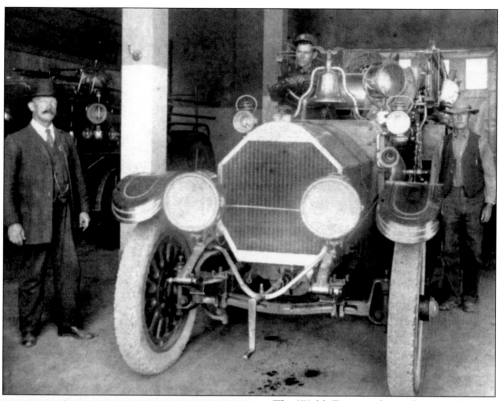

The Webb Engine, shown here in 1913, was the pride of the San Mateo Fire Department. To the left is Chief Bartlett, with driver Frank Pease behind the wheel and Fireman John Gothard to the right.

San Mateo city marshal Maurice F. Boland's reputation in 1904 San Mateo was that of an honest, steadfast, and fearless man who left nothing to be desired in the administration of his duties. He was the third appointed marshal after the city incorporated in 1894, serving from 1902 to 1913.

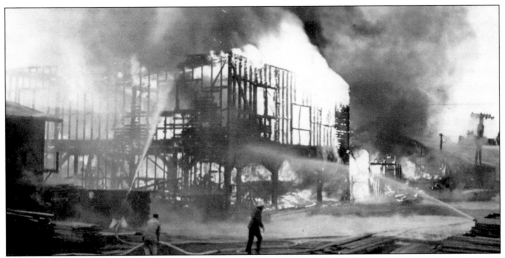

Pederson and Arnold Lumber caught fire on January 11, 1947. The subsequent investigation revealed the fire to be the work of a 12-year-old arsonist.

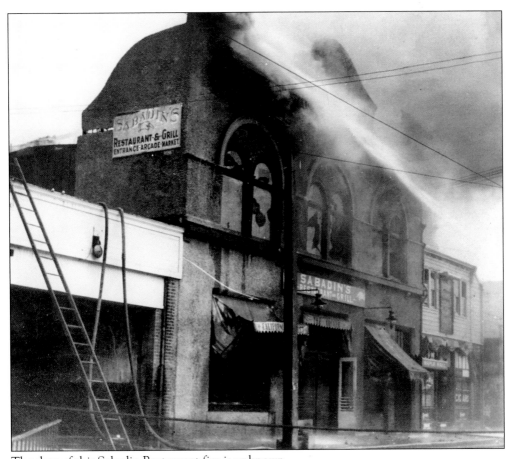

The date of this Sabadin Restaurant fire is unknown.

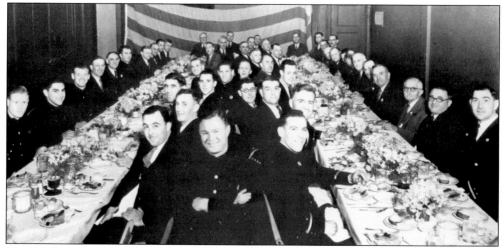

This celebration for Fire College graduates in June 1934 included Judge Aylett Cotton, City Manager Earl Wilsey, Jay Stevens, Hugh Morris, Jack Gibson, Francis Meyer, Noe Chanteloup, Martin Boyle, Gene Thiele, George Parkman, Milt Axe, Earl Beecher, Police Chief Tom Burke, Elmer Wright, Seth Cohn, Morris Powers, Dick Boerner, Gene Commozzi, Cecilo Morris, Einar Peterson, Henry Henrioulle, Joe Garbini, Frank McGuire, Harry Baldwin, Jim Williams, Emil Stein, Bruce Gibson, Raoule Courtin, and Luis Degan.

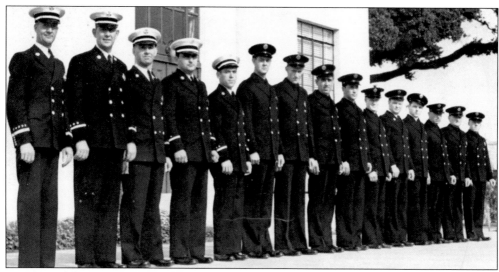

Members of the San Mateo Fire Department in 1940 included Chief Hugh F. Morris, Assistant Chief Elmer Wright, Assistant Chief Richard Boerner, Capt. Henry Henrioulle, Capt. Noe Chanteloup, Firemen Cecil Morris, Howard Petersen, Harry Baldwin, James Jacques, Fire Alarm Supervisor Jack Gibsen, Fire Inspector Francis Meyer, Firemen Willis Lemon, Richard Greening, Martin Boyle, and Fire Mechanic Einar Peterson.

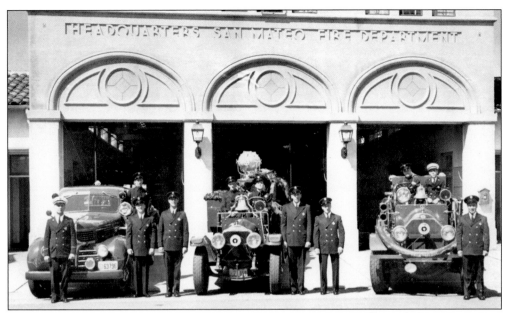

Posing in front of the San Mateo Fire Department's main station on Ellsworth Avenue in 1942, from left to right, are (front row) Assistant Chief Richard Boerner, Milton F. Walker, Cecil Morris, Roy Toschi, Joe Canzian, and Jay Meghinasso; (back row) John Canzian, Howard Peterson, Peter Fogli, Otto Kutzer, and Capt. Noe Chanteloup.

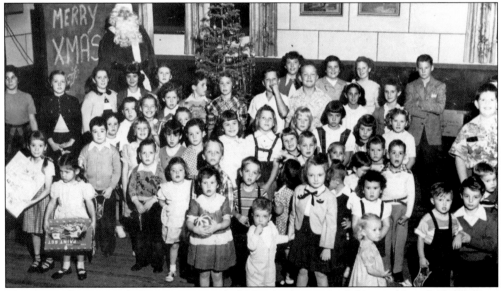

This December 1951 Christmas party was held for the firemen's children, although the firemen of San Mateo do not just have parties for their own children now. Their widely expanded year-round program is dedicated to bringing holiday cheer to over 10,000 needy children. During the period between Thanksgiving and Christmas, personnel contribute their off-duty hours to operate Santa's workshop. Toys may be dropped off at any fire station at any time of the year. In addition to the toy program, the San Mateo Fire Department provides toys to juvenile fire victims and honors special requests. After the 1989 Loma Prieta Earthquake, toys from this program were given to 2,000 children living in the Santa Cruz and Salinas areas.

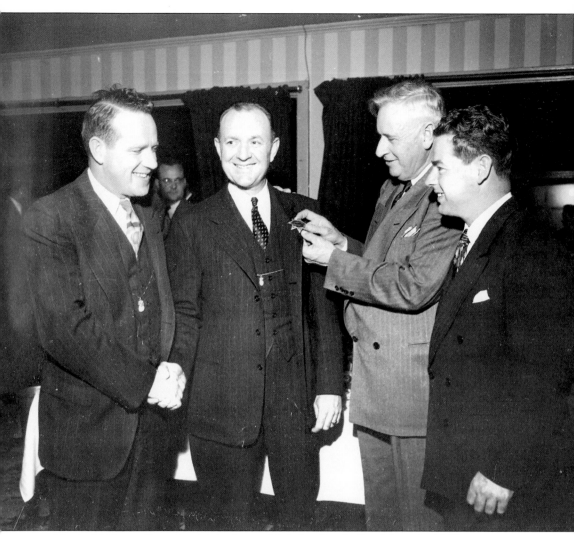

Martin McDonnell receives his badge as chief of police for San Mateo in 1957.

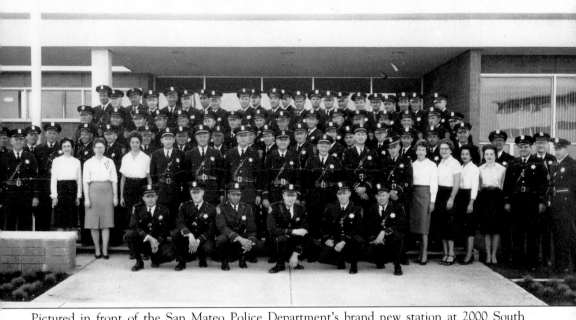

Pictured in front of the San Mateo Police Department's brand new station at 2000 South Delaware on March 7, 1962 are, from left to right, (first row) Bob Hanson, John Burr, Conrad Caines, Lous Del Grande, Bill Hurley, and Bert Sellers; (second row) Sgt. Howard Trickett, Betty Gilberg, Julia Gray, Linnea Swartz, Lt. Bill Condon, Capt. Clarence Silva, Department Chief Bud Kohnen, Chief Martin McDonnell, Capt. Bill Andreasen, Lt. George Condon, Lt. Harold Bogan, Irene Wight, Alice Thorne, Alicia Gibo, Judy Jones, Sgt. John Borcherding, and Sgt. Gordon Hall; (third row) Sgt. Walt Otten, Sgt. Stan Cohlean, Sgt. Tom McDaniel, Loyal Brummet, Dick St. Clair, Herman Neuman, Jerry Sheehan, Dick Lassell, Bernie Hovorka, Bill Konohoe, Charlie Drews, Don Werner, John Smyrnos, Roy West, Jerry Whaley, Al Ajuria, Walter Barth, Sgt. George Andeasen, and Sgt. Bob Condon; (fourth row) Gordon Sheehan, Jimmy Allen, Dick Ryan, Don Villnow, Dick Hansen, Ted Lydon, John Cameron, Tom Charity, Bill Scott, Dick Bonds, Howard Darknell, Freddie Gibbons, Bob Bennett, Ted Hegedus, Tom Cantrell, and John Pawson; (fifth row) Wally Cather, Bill Oakes, Ev Pence, Glen Bale, Leo Minehan, Marvin Bullis, Dick Harrison, Sam Foresman, Frank Lohmeier, Jim Steinrok, Guido Piacente, Mike Bonnie, Ed Kralich, Gordon Joinville, Tom Dilbeck, Larry Loreau, Ed Swetlik, Dick Lust, Serge Leonhardt, Bob Hailer, Pete Eughart, and Larry Weissel.

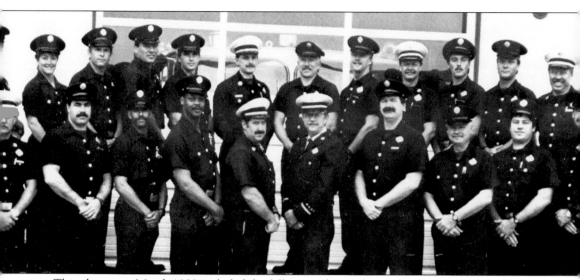

This platoon in March 1989 included the following, from left to right: (front row) Tim O'Brien, Mike Quenneville, Mark Greene, Mike Rogan, Rich Delucchi, Harry Burton, Kurt Halliday, Charles Hall, Jeff Barile, and John Warren; (back row) John Smith, Jill Correll, Ed Hawkins, Greg Campbell, Greg Boyle, Dave Lochner, Mike Gero, Bill Calkins, Cal Eitel, Jim Snider, Mark Harvery, and Joe Latham.

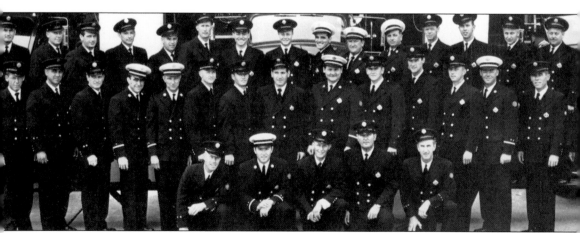

Shown here, from left to right, are (front row) John Sullivan, Wayne Alexander, Ron Castle, Joe Henley, and Lionel Washburn; (middle row) Leonard Calvert, Michelangelo Pagano, Jim Sutcliffe, Joe McCann, Ed Medaugh, Dave Naslund, George Franklin, PeterMcEntee, Dale Panter, Bruce Gidea, Dennis Callahan, Harry Burton, Jim Byrnes, Richard Olsson, and William Dreislein; (back row) Dick Waitron, Don Harley, Al Sebastian, Jim McKillop, Charles Smith, Andrew Larsen, Charles Pellizer, Wayne Shoemaker, Art Koron, Eloi Chateloup, Rudy Duncan, Richard Spillane, John Von Almen, Ray Kniffin, and Paul Ward.

Three

FAMOUS FACES

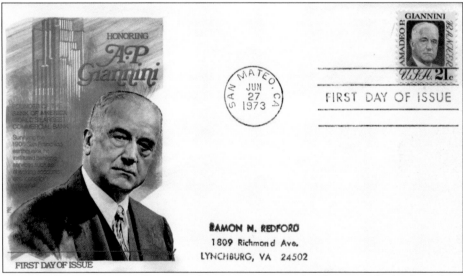

In 1904 Amadeo P. Giannini, a former produce businessman with only a year of high school, founded the Bank of Italy in San Francisco when he was still in his thirties after a brief time as secretary of San Mateo Bank. In the aftermath of the earthquake and fire of 1906, Giannini personally saved about $2 million in gold and securities by camouflaging it and taking it to his San Mateo home by horse and wagon while maneuvering through looting crowds and rubble. Unable to open the safe containing the bank records until much later (because the paper would instantly have disintegrated they way it had at other banks), Giannini took the word of the people who had invested with him and loaned out money with no collateral except the word of his clients, something no other banker would have dared to do. That trust led to expansive growth. His solicitation of the common worker and willingness to make loans where other banks would not led to his bank's popularity. The name was changed to Bank of America in the 1920s. Giannini continued to live in San Mateo and, before his death in 1949, saw his venture grow to become the world's largest bank.

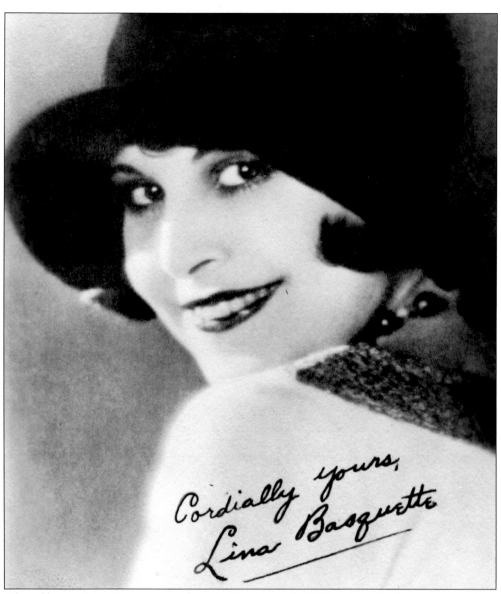

Cordially yours,
Lina Basquette

Silent film star Lina Basquette was born in San Mateo in 1907 as Lena Baskette, the daughter of the proprietor of Baskette's Drug Store. She began her career in show business as a child ballerina at the 1915 San Francisco Panama-Pacific International Exposition, then appeared in a series of short films for Universal entitled *Lena Basquette Featurettes*. By 1923 she had given up films to pursue her dancing career, eventually becoming the featured lead dancer in the renowned *Ziegfeld Follies* at only 16 years of age. Two years later she married Sam Warner of Warner Brothers and had a son the next year. In 1927 Warner died and a bitter battle over his estate and custody of the couple's infant son ensued. Basquette lost both to the powerful Warner family. In 1929 she starred in Cecil B. DeMille's last silent film *The Godless Girl*. In the 1930s she was Adolph Hitler's favorite actress and was personally invited to Germany. She retired in the 1940s although she occasionally played minor roles until shortly before her death. Married a total of six times, Lina Basquette died from lymphoma in October 1994. She was truly San Mateo's first superstar.

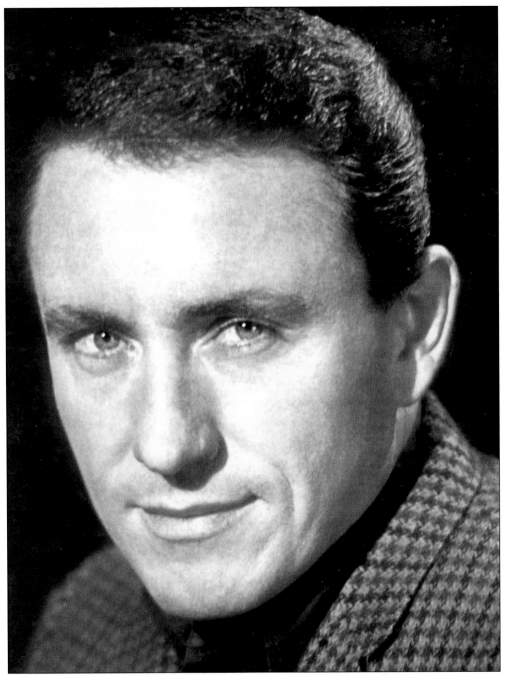

Born in San Mateo on July 6, 1925, Mervin Griffin Jr. lived on El Dorado Street and graduated from San Mateo High School and the College of San Mateo. He frequently played the organ for weddings at Old St. Matthew's Catholic Church and got his first break singing at KFRC radio in San Francisco in 1945. He was a vocalist with Freddy Martin's Orchestra from the late 1940s until 1951 although he is best remembered for hosting *The Merv Griffin Show* from 1965 to 1986. He received numerous Emmy Awards and is the creator of the perennially favorite games shows *Jeopardy* and *Wheel of Fortune*.

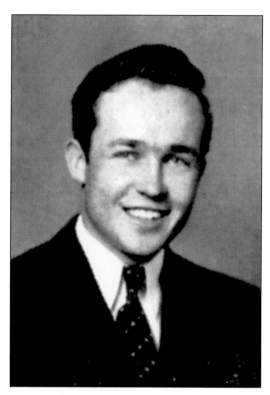

Abstract expressionist artist Sam Francis (1923–1994) is pictured here in his yearbook photo from San Mateo High School in 1941. Francis rose to prominence in the art world as an abstract expressionist painter using non-objective forms and color. Abstract expressionism is considered to be the first American artistic movement of worldwide importance and includes among its followers the legendary Jackson Pollock. Francis's work is displayed in many prominent museums, among them the National Gallery of Art in Washington, D.C., the Fine Arts Museums of San Francisco, the Norton Simon Museum in Pasadena, and the Tate Gallery in London.

Born in 1954, Neal Schon attended Aragon High School. In 1971 he joined the legendary rock group Santana and later became one of the founding members of Journey. Schon, who began playing the guitar at age 10, has become one of the most enduring rock stars of all time.

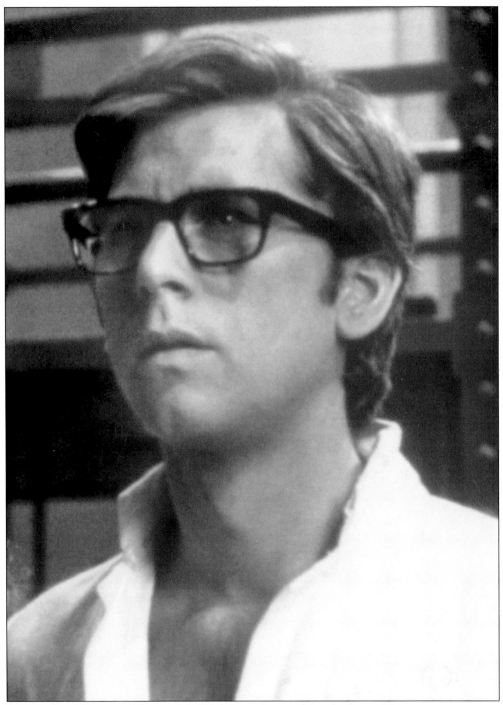

Born in San Mateo on February 24, 1946, Barry Bostwick has had a prolific career as an actor. His filmography contains numerous credits; as early as 1968 he had a role in an episode of the TV series *Hawaii 5-0*. He is perhaps best remembered for one of his other earlier roles, that of the naive Brad (pictured here) in *Rocky Horror Picture Show* (1975), which has become a cult classic. Another memorable role is that of the mayor in the hit TV series *Spin City*.

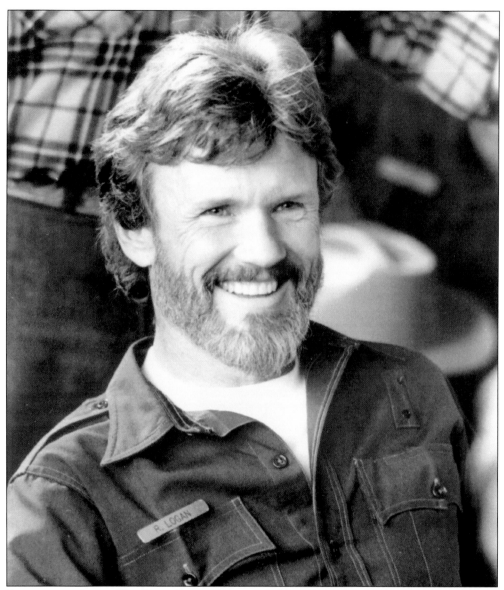

Songwriter and actor Kris Kristofferson also attended San Mateo High School. Although born in Brownsville, Texas, in 1936, Kristofferson moved around a lot as a child since his father was a U.S. Air Force general. Both a Rhodes Scholar and a Golden Gloves boxer, the young Kristofferson joined the army and learned to pilot helicopters. He left the service in his mid-twenties to pursue his songwriting career. Early on, he met Johhny Cash in Nashville. Legend has it that Cash mostly ignored the young songwriter until Kristofferson, then a commercial helicopter pilot, landed a copter in Cash's backyard and gave him tapes of his songs. Cash then recorded Kristofferson's "Sunday Morning Coming Down," which was awarded "Song of the Year" by the Country Music Association in 1970. Married three times, Kristofferson has eight children. His second wife was the famous country singer Rita Coolidge, whom he divorced in 1976. In his numerous films, Kristofferson starred as Billy the Kid in 1973's *Pat Garrett and Billy the Kid* and in the Western epic *Heaven's Gate*. One of the roles he is best remembered for is as a doomed rock star in the 1976 version of *A Star is Born*, co-starring Barbra Streisand.

Four

SOCIAL LIFE

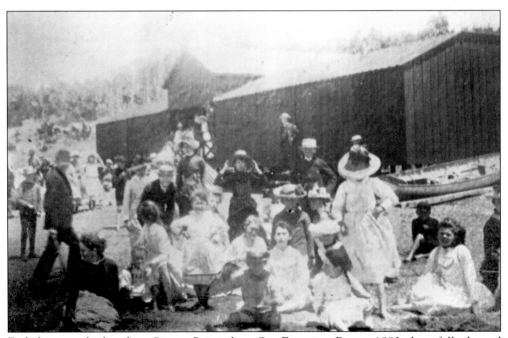

Frolicking on the beach at Coyote Point along San Francisco Bay, *c.* 1880, these fully dressed folks are in front of the bathhouse that rented bathing suits.

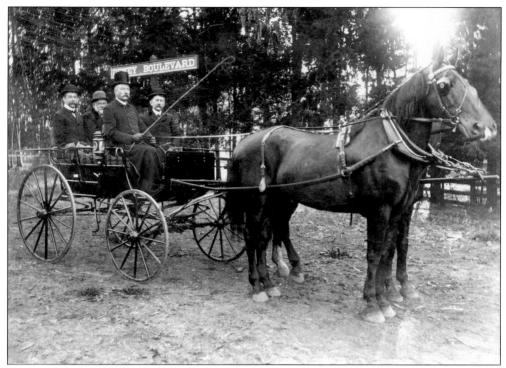

A group of "hardware big shots from the East" are treated to a carriage tour of Coyote Point by "Big Bob" Wisnom in the early 1900s.

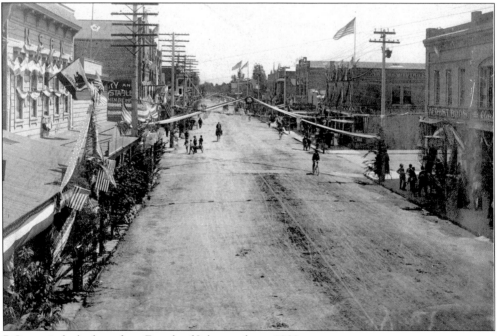

B Street is decked out for a Fourth of July parade, c. 1900.

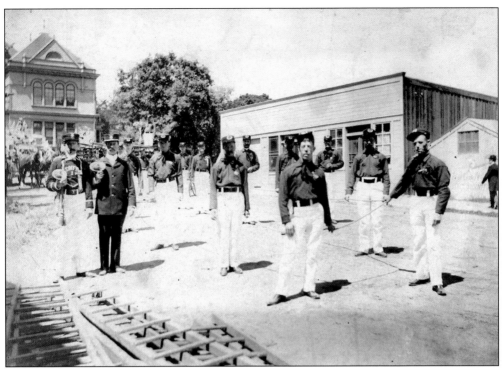

Cadets assemble in formation for the Fourth of July Parade, c. 1900.

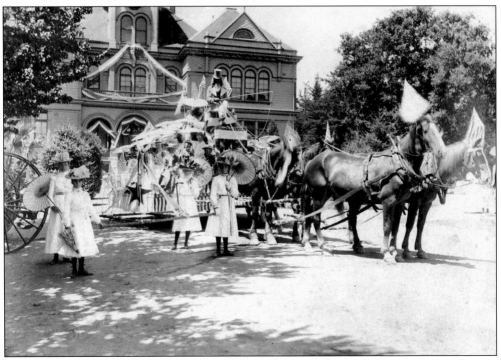

As part of the Fourth of July Parade, a contingent of young ladies with decorated parasols await their cue to march.

This excerpt from a 1904 advertisement for the Hotel Mateo Club House reads

Located on the beautiful grounds of the Hotel Mateo, hid in a nest of oaks and vines is located the Hotel Mateo Club House, conducted by Oscar Courtin. This popular resort has since its inception received the visits of high class patronage drawn hither by the quiet, beautiful surroundings and the bon-homme of the manager. The premises are tastefully and conveniently fitted up (with) bowling alleys, pool and billiard tables for use of patrons, making it one of the most handsomely appointed clubhouses in the city. All the most popular brands of wines, liquors, beers, cigars, etc. are carried in stock, and that which is served is of the very best.

Hotel Mateo Club House proprietor Oscar Courtin was described in 1904 as "the genial proprietor of Hotel Mateo Club House," who was "favorably known and has a host of friends who pay their personal visits. The public visitors to San Mateo will always find this an agreeable place to visit thanks to Mr. Courtin."

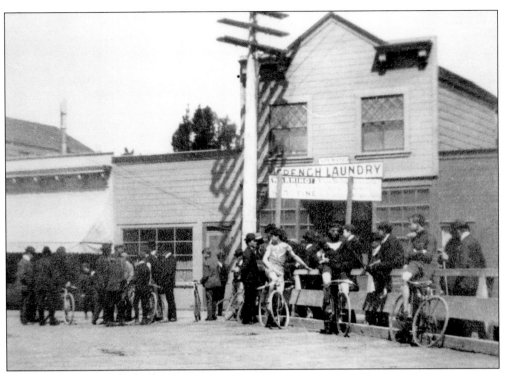

This bicycle race on the bridge at B Street and Baldwin Avenue took place c. 1908.

The Elks Club broke ground in 1908 for a clubhouse located on the west side of B Street between Third and Fourth Avenues. A parking garage now occupies the site. The Elks Club built new facilities on Twentieth Avenue in 1954, which they continue to use to this day.

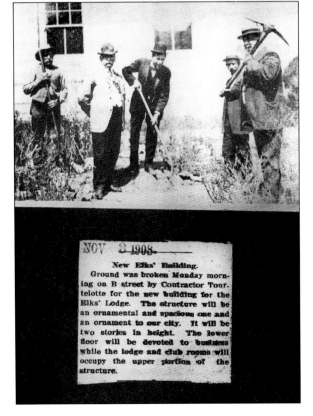

NOV 3 1908.

New Elks' Building.
Ground was broken Monday morning on B street by Contractor Tourtelotte for the new building for the Elks' Lodge. The structure will be an ornamental and spacious one and an ornament to our city. It will be two stories in height. The lower floor will be devoted to business while the lodge and club rooms will occupy the upper portion of the structure.

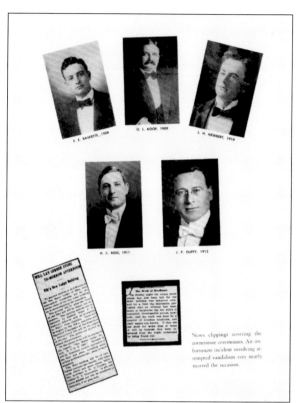

Elks Club rulers in 1908, from left to right, were (bottom row) H.C. Ross (1911) and J.P. Duffy (1912); (top row) F.E. Baskette (1908), C.L. Koop (1909), and L.W. Newberg (1910). The dates in parentheses refer to the year in which the man was Grand Exalted Ruler.

News clippings covering the cornerstone ceremonies. An unfortunate incident involving attempted vandalism very nearly marred the occasion.

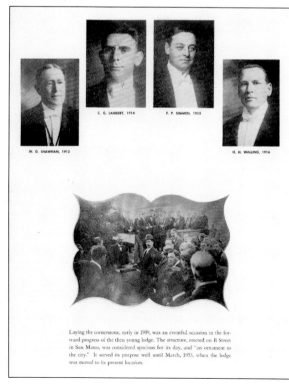

Laying the cornerstone, early in 1909, was an eventful occasion in the forward progress of the then young lodge. The structure, erected on B Street in San Mateo, was considered spacious for its day, and "an ornament to the city." It served its purpose well until March, 1955, when the lodge was moved to its present location.

Other early rulers of the Elks Club, shown here in 1908, from left to right, were W.D. Shawhan (1913), C.G. Lambert (1914), H.P. Simmen (1915), and H.H. Walling (1916).

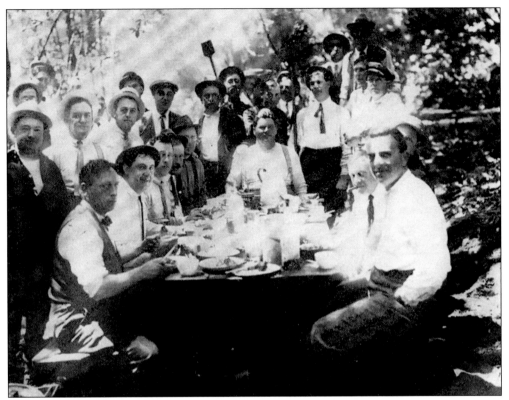

This Elks Club breakfast took place on June 18, 1911.

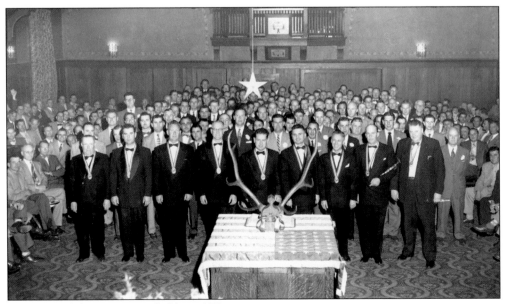

This Elks Club meeting was held in 1958.

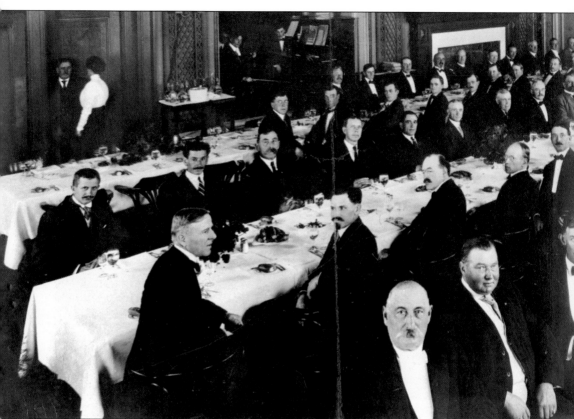

The annual board of trade banquet was held at the Peninsula Hotel on August 8, 1912. In attendance, from left to right, were (first row, bottom right) F. Levy, Asa Hull, and Jack Peckham; (second row) Dr. Baker, unidentified, Chidester, two unidentified men, and E. Levy; (third row) Perichon, Rognier, J. Levy, Carlson, Rossetti, Zachman, Chamberlain, Walsh, Buckman, and Hart; (fourth row) unidentified, Bonner, R.J. Wisnom, two unidentified men, Johnstone, two unidentified men, Kirkbride, Anderson, Fisher, Gordon, and unidentified; (fifth row) Rochex, Wiseman, Adams, Bromfield, three unidentified men, and Brown. Standing is Mr. Doolittle speaking with a woman in a white blouse with her back to the camera. The unidentified musicians await their cue in the alcove in the background. (Photo by Eastern Art Company, 34 Ellis Street, San Francisco.)

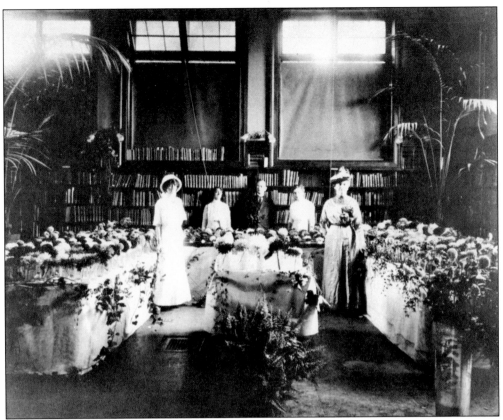

This dahlia show took place at the San Mateo Public Library in 1914.

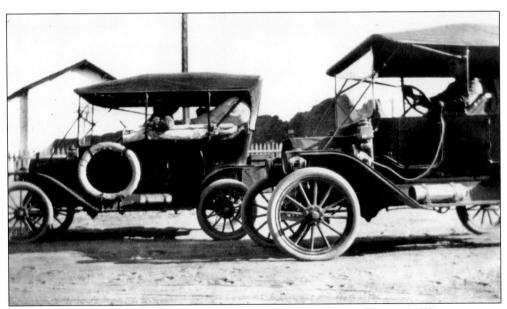

Mr. Dado and Mr. Merkel purchased their new 1913 automobiles at Wisnom's. The two appear to be readying for a race; top speed will be around 30 miles per hour.

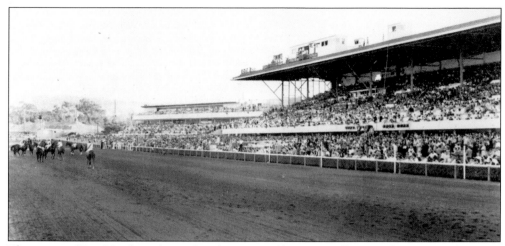

This image of Bay Meadows shows that the "sport of kings" is still as popular as ever, playing to a full crowd in the mid-1930s.

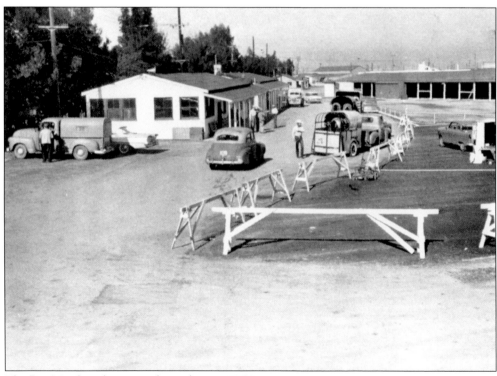

The Bay Meadows barns are shown here *c.* 1959.

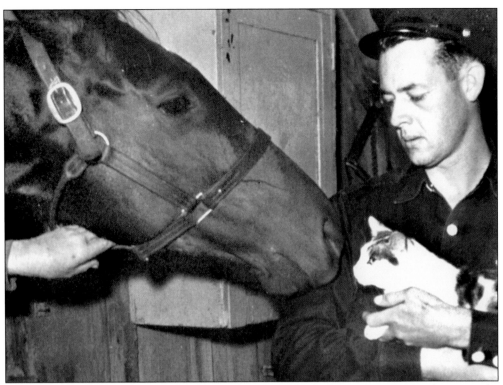

Cecil Morris and friends visit while on fire detail at Bay Meadows, c. 1959. By that year, the racetrack was being manned around the clock by the San Mateo Fire Department.

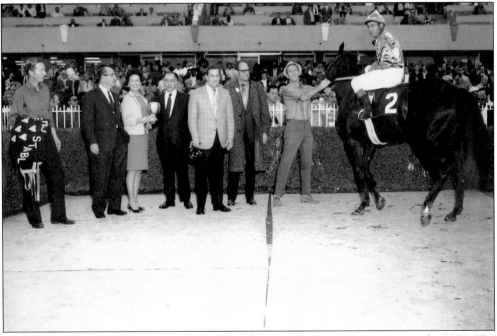

On October 31, 1970, Ulla Britta was declared the Bay Meadows Winning Horse for 1970. The man on the far left holds a garland of roses to be placed around the horse's neck.

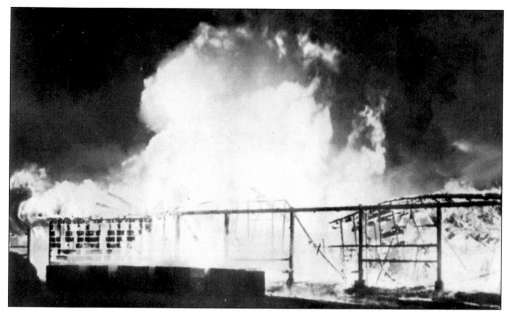

When the Bay Meadows barns erupted in flames on October 19, 1956, no horses were housed in these particular buildings. Only structural damage was sustained.

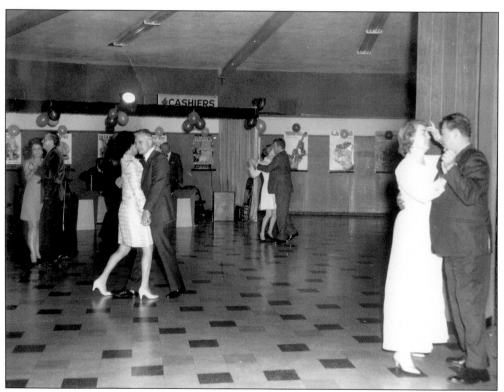

Bay Meadows was not only a racetrack but a venue for socializing as well, as evidenced by this party held in the main lobby in 1962.

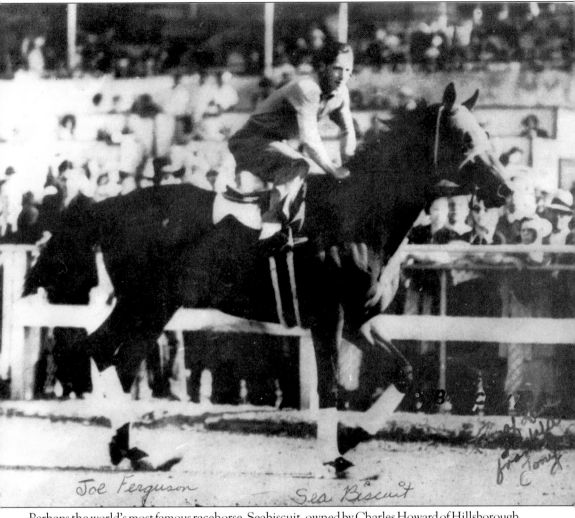

Joe Ferguson Sea Biscuit

Perhaps the world's most famous racehorse, Seabiscuit, owned by Charles Howard of Hillsborough, is shown racing at Bay Meadows sometime in the 1930s.

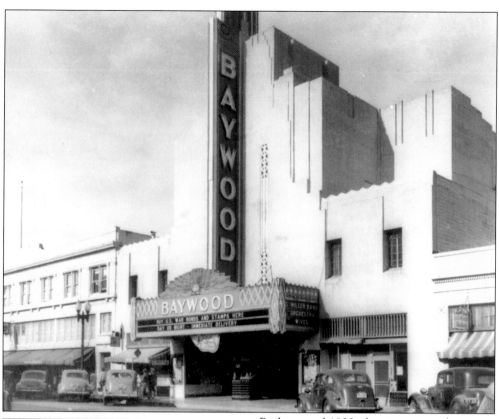

Built around 1930, the ziggurat art deco showplace Baywood Theatre was a centerpiece of San Mateo's recreation during the Depression. Situated on the east side of B Street between Third and Fourth Avenues, it is shown here around 1944. Later it became Thrifty's drugstore. The building still stands.

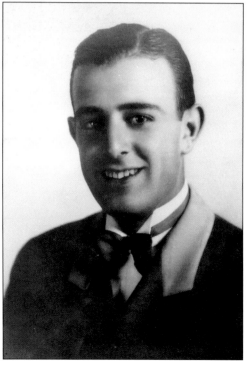

Nicholas Zompolis was the manager of the Baywood Theatre in 1933 when he was only 20 years old. He later went on to become a deputy sheriff for San Mateo County.

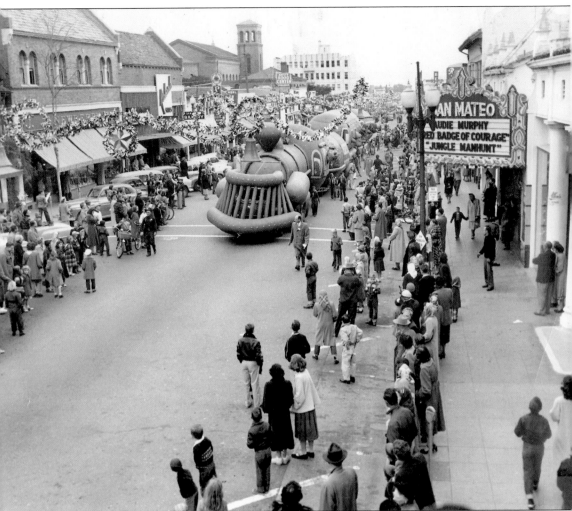

This Christmas parade down Third Avenue is estimated to have taken place around the mid-1950s. Dave McCullough, the town's premier sign painter, invariably played the quintessential Santa Claus. Once, when arriving by helicopter in Central Park's baseball field and waving to all the kids in the stands he got his hand hit by the rotor. Always the showman, he acted as if nothing had happened so the children wouldn't be upset. Yearly, he would take his post in Levy Brothers window and listen to the Christmas requests of thousands of San Mateo's children.

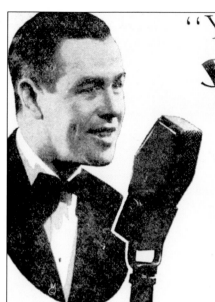

"YOUR TOWN"
SAN MATEO

——ON THE AIR!——

TO-NIGHT
8 to 8:45 O'clock

K Q W ... San Jose
740 ON YOUR DIAL

PRESENTED BY
All - Pure Milk Co.

HEAR: the progress and colorful story of San Mateo paid tribute!

Listen to the fascinating historical background of "Your Town" ... of San Mateo

Featuring these Local Personalities:

JEAN ALOISE

San Mateo's own popular . . . and petite . . . Tap Dancer . . . dancing to the tune "I Don't Want to Set the World on Fire."

DUKE CAMPAGNA

San Mateo orchestra leader, playing piano solo of his own composition, "When" . . . with Bill Vawter, singing the vocal refrain.

PATTY BOYLE
JAMES TIERNEY

RAY DABA
JUNE BREWER

San Mateo dramatic group, in a specially written comedy sketch

Attend Free Broadcast - Montgomery Theatre
Civic Auditorium - San Jose

This Program is Made Possible thru Your Continued Use of

ALL-PURE MILK

This full-page ad for a radio show from San Jose showcasing San Mateo dates from 1943.

This 1943 newspaper article alerted citizens to the big event when San Mateo would be the featured city on the radio, just in case someone had missed the full-page ad.

'YOUR TOWN' PROGRAM TO HONOR S. M. TONIGHT

How well do you know San Mateo? To know it better, listen to KQW tonight from 8 to 8:45 o'clock or better yet, go to the Montgomery theatre in the civic auditorium at San Jose.

San Mateo will be featured on the "Your Town" broadcast sponsored by the Meyenberg company, producers of All-Pure evaporated milk products, in a program including local speakers and musicians.

On the broadcast will be Jean Aloise, popular young San Mateo tap dancer; Duke Campagna, San Mateo orchestra leader and composer, who will play a piano solo of his own new composition, "When," with refrain to be sung by Bill Vawter, San Mateo junior college student and popular vocalist, and a comedy sketch to be presented by a San Mateo dramatic group: Patty Boyle, Ray Daba, James Tierney and June Brewer, who have appeared with the Hill Barn players.

Dedicating the program and an-swering questions about San Mateo will be Randle Shields, secretary-manager of the chamber of commerce. Questions and answers will be given on the history and growth of San Mateo during the past 50 years.

Tribute to City

In addition to the appearance of local people on the broadcast program there will be selections by Dr. Richards' glee club of 24 businessmen from San Jose, and Clyde Appleby's 14-piece orchestra. Robert Robb will act as master of ceremonies.

The "Your Town" programs, featuring a tribute to the cities of the central coast area, have been sponsored by the Meyenberg company for the past 20 weeks.

In response to an invitation from the sponsors and the studio, a delegation of San Mateans will attend the broadcast.

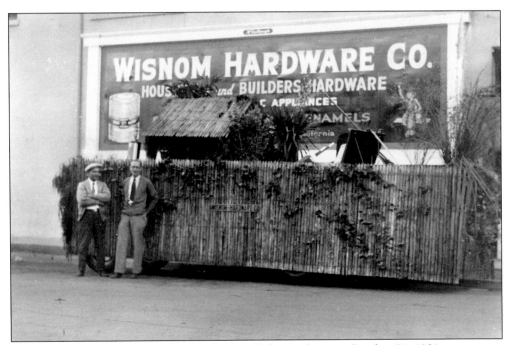

Wisnom's entered this exotic float in the annual flower show on October 24, 1931.

A popular place for the teenage crowd of the early 1960s, Kibby's was a coffee shop with a drive-in feature. Below is the interior of Kibby's menu, *c.* 1962.

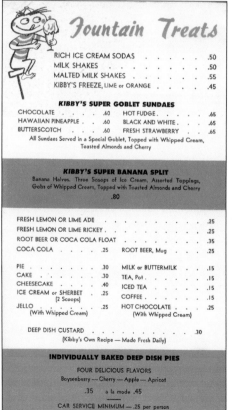

Fountain Treats

RICH ICE CREAM SODAS	.50
MILK SHAKES	.50
MALTED MILK SHAKES	.55
KIBBY'S FREEZE, LIME or ORANGE	.45

KIBBY'S SUPER GOBLET SUNDAES

CHOCOLATE	.60	HOT FUDGE	.65
HAWAIIAN PINEAPPLE	.60	BLACK AND WHITE	.65
BUTTERSCOTCH	.60	FRESH STRAWBERRY	.65

All Sundaes Served in a Special Goblet, Topped with Whipped Cream,
Toasted Almonds and Cherry

KIBBY'S SUPER BANANA SPLIT

Banana Halves. Three Scoops of Ice Cream, Assorted Toppings,
Gobs of Whipped Cream, Topped with Toasted Almonds and Cherry

.80

FRESH LEMON OR LIME ADE	.25
FRESH LEMON OR LIME RICKEY	.25
ROOT BEER OR COCA COLA FLOAT	.35
COCA COLA .25 ROOT BEER, Mug	.25

PIE	.30	MILK or BUTTERMILK	.15
CAKE	.30	TEA, Pot	.15
CHEESECAKE	.40	ICED TEA	.15
ICE CREAM or SHERBET (2 Scoops)	.25	COFFEE	.15
JELLO (With Whipped Cream)	.25	HOT CHOCOLATE (With Whipped Cream)	.25

DEEP DISH CUSTARD30
(Kibby's Own Recipe — Made Fresh Daily)

INDIVIDUALLY BAKED DEEP DISH PIES

FOUR DELICIOUS FLAVORS
Boysenberry — Cherry — Apple — Apricot

.35 a la mode .45

CAR SERVICE MINIMUM — .25 per person

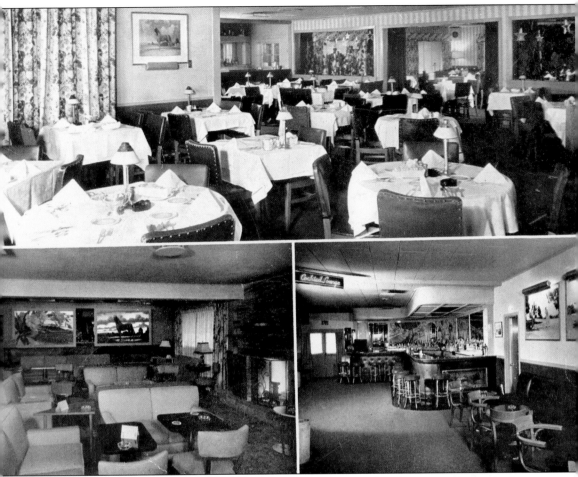

This c. 1955 postcard shows three views of the Villa Chartier, the elegant restaurant in the Villa Hotel.

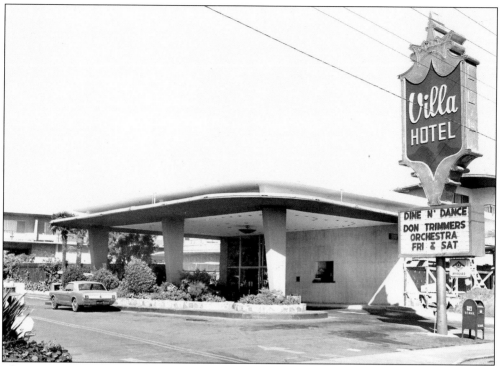

This image shows the Villa Hotel entrance around 1955.

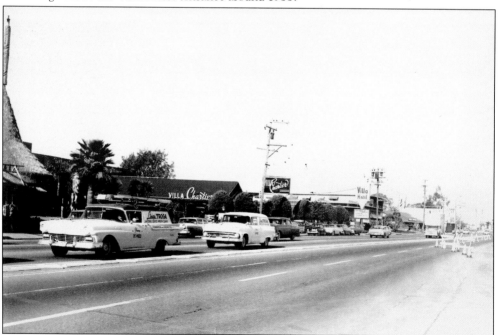

Located along El Camino Real between Fortieth and Forty-first Avenues, Villa Square was a complex including the luxury Villa Hotel, fine restaurants, and bars. Shown here in the 1950s, it remains much the same today, although with some additions and renovations. It is now owned by the Radisson chain.

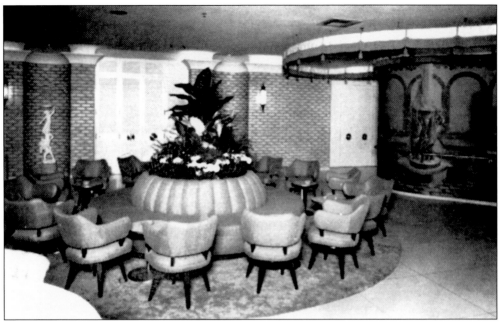

The Villa Chartier Terrace Bar provided an elegant place to relax and have a drink.

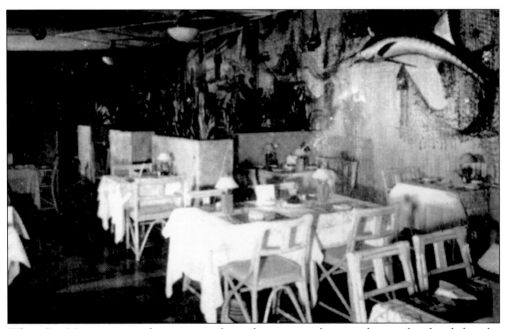

When San Mateans wanted to go somewhere glamorous and extraordinary, they headed to the Villa Hotel's Lanai Restaurant, which was part of the Villa complex. With its jungle theme and rock wall waterfall, it brought the tropics to San Mateo along with savory Cantonese dishes. It was like nowhere else in town, and unfortunately was torn down in the mid-1980s.

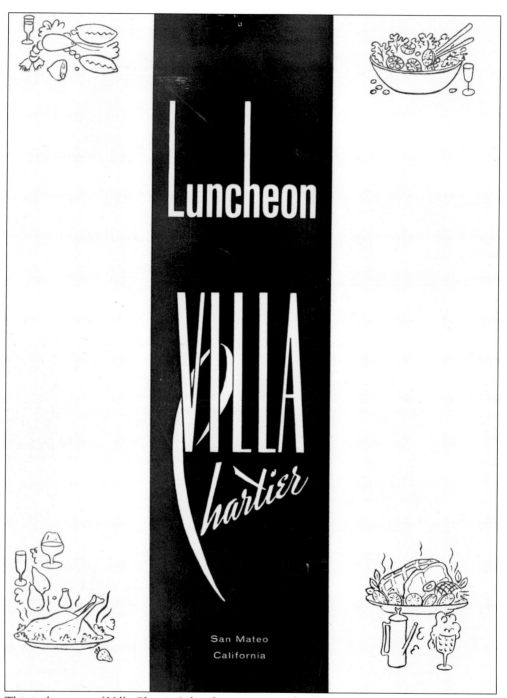

Luncheon

VILLA Chartier

San Mateo
California

This is the cover of Villa Chartier's luncheon menu in the 1960s.

Appetizers

New Orleans Oysters on the Half Shell. Served October through March .	$1.00
Served on cracked ice — special cocktail sauce	
Fresh Whole Cracked Crab with Mayonnaise, Roll and Butter. In season .	1.75
Fresh Half Cracked Crab with Mayonnaise, Roll and Butter. In season .	1.25
Shrimp Cocktail, Supreme . .65 Crabmeat Cocktail, Supreme .	.75
California Fruit Cocktail . . .50	

Salads

Special Chef's Salad Bowl with Seafood, Chartier Dressing	1.65
Combination Fresh Vegetable, Chartier Dressing	1.45
Ripe Avocado Filled with Seafood or Chicken Salad	1.75
Fresh Crabmeat or Gulf Shrimp Salad, Choice of Dressing	1.65
Farm Fresh Cottage Cheese, Choice of Fruit	1.50
Sliced Tomatoes50 Crisp Mixed Green Salad . .	.50

Special Sandwiches

Tunafish Salad Sandwich . .	.75	Virginia Baked Ham90
Sliced Breast of Turkey . .	1.25	Imported Swiss Cheese on Rye	1.25
Baked Ham and Cheese . .	1.25	Lettuce and Tomato75
Bacon, Tomato and Lettuce .	1.00	American Cheese75
Deluxe Clubhouse (3 Decker)			1.50
Combination Baked Ham, Turkey and American Cheese			1.65

All Sandwiches Richly Garnished

Hot Sandwich Plates

Melted American Cheese with Bacon	1.25
Hot Turkey Sandwich with Mashed Potatoes, Gravy and Cranberry Sauce .	1.25
Hot Roast Beef Sandwich, Potatoes and Gravy	1.25
Hamburger Steak Sandwich on Toast with Sliced Raw Onion, French Fried	
Potatoes	1.25
New York Cut Steak Sandwich with French Fried Potatoes, Sliced Tomatoes	2.65

A la Carte Entrees

Includes Chef's Salad — Rolls and Butter

Two Eggs, any style, Toast and French Fried Potatoes	1.25
Fresh Mushroom Omelette	1.75
Ham or Bacon and Eggs, any style	1.75
French Fried Prawns with Cocktail Sauce	1.75
Broiled Double Lamb Chops	3.75
Broiled New York Steak	4.50
Half Disjointed Chicken Saute, Fresh Mushrooms	2.50
Ground Sirloin Steak Smothered with Onions	1.90

Desserts

Sherbet25	Ice Cream25
Parfait50	Homemade Berry and Apple	
Pie a la Mode40	Pies baked in our own ovens	.25

Beverages

Coffee, per cup20	Milk20
Tea, Hot or Cold20		

Here is the inside of the same menu.

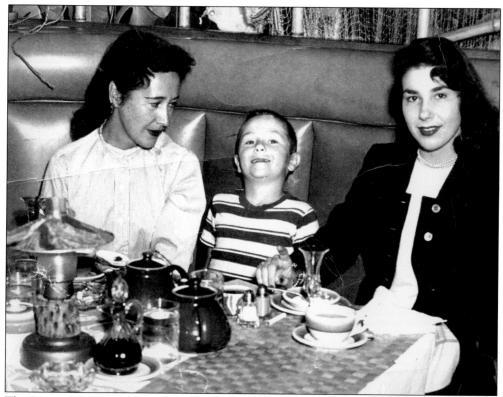

The Morse family of Hillsborough enjoys the exotic fare at Lanai Restaurant in May 1954. Shown, from left to right, are Madelyn, Jimmy, and Sherry Morse.

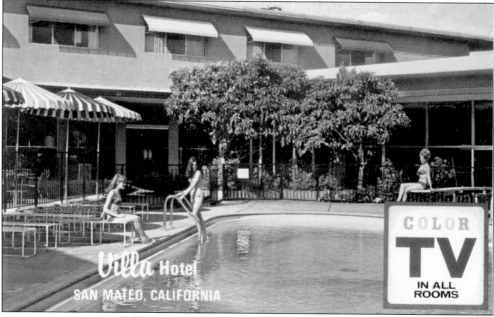

Perched alluringly around the Villa Hotel pool in 1967, it is doubtful that these beauties are going to get their perfectly coiffed hair wet.

Five

HOMES AND FAMILIES

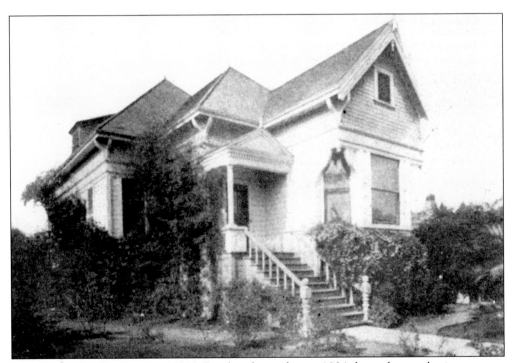

This home of real estate agent H.N. Royden shows that in 1904 the real estate business was as lucrative then as it is now for those who were knowledgeable and determined to provide good service. Acknowledged by his peers to be notably successful, Royden was also public spirited in all matters pertaining to the general welfare of San Mateo.

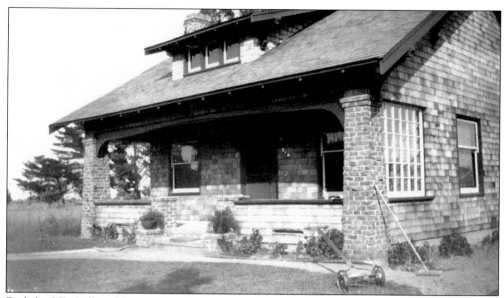

Built by J.F. Coll and his new bride, the former Dorothy Chalmers, this bungalow was one of the first to be built in the new subdivision of Hayward Park, c. 1912. Located behind the swank Peninsula Hotel, which burned down in 1920 and was formerly the Alvinza Hayward estate, the homes are located on what was once the estate's deer paddock. Designed in the Arts and Crafts style, this home has remained in the Coll family until this day and is presently occupied by J.F. Coll's grandson. It is possibly the longest continually occupied home by one family in San Mateo. A great deal of its original features remain intact.

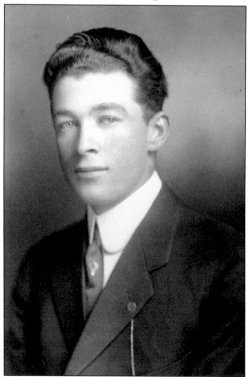

Joseph F. Coll, shown here around 1911, was born in San Francisco in 1887. Orphaned by the time he was eight, he and his siblings came to San Mateo in 1896 to live with their aunt, Ellen Coffey, on Griffith Avenue (now San Mateo Drive). Coll attended San Mateo High School, graduating in 1905, and was a jeweler with Krementz and Company. He passed away suddenly in 1948 in his beloved home in Hayward Park.

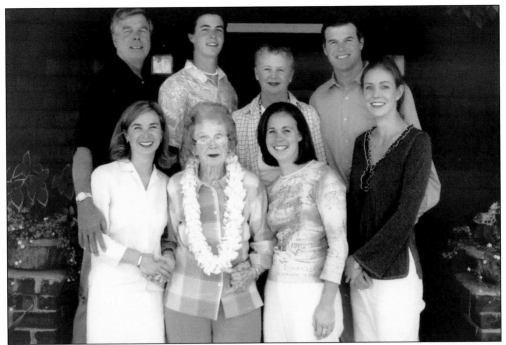

Born in the back bedroom of the Coll bungalow in 1913, Dorothy Coll Funke celebrates her 90th birthday in 2003 in the home in which she was born, a claim that few can make. A champagne toast at the exact time of her birth took place in the bedroom in which she made her entrance into the world. Pictured, from left to right, are (front row) granddaughter Michelle Young, Dorothy Coll Funke, granddaughter Megan Young, and Coll's grandson's wife, Jacy Young; (back row) son-in-law Bob Young, grandson Rory Young, daughter Eileen Funke Young, and grandson Matthew Young.

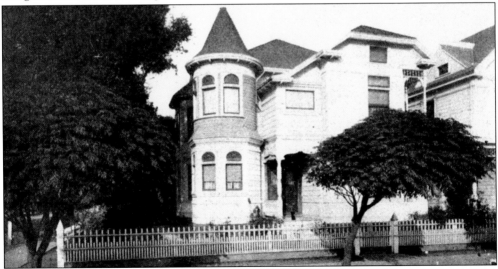

Pictured here is the R.H. Jury Residence (location unknown). Richard Jury was one of the founders of San Mateo's first newspaper, *The Leader*. The paper eventually was sold and went through a number of mergers, the final one with the *San Mateo Times*. Jury eventually became a California state assemblyman.

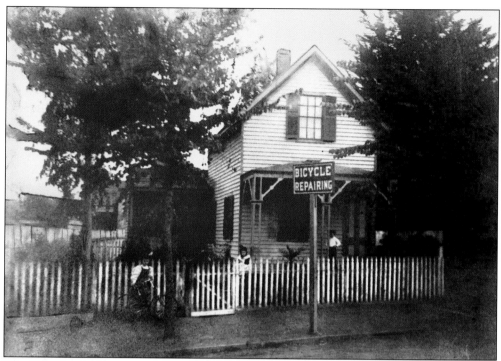

The Gary family home was located on the southeast corner of First and Ellsworth Avenues (date unknown).

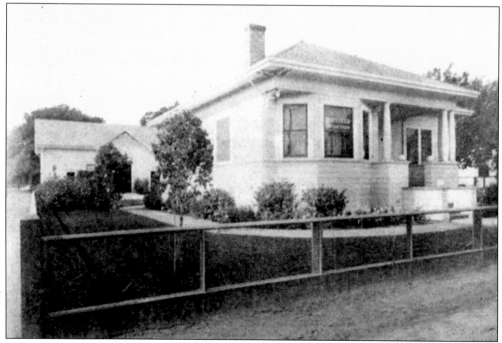

This photo of the home of Dr. C.W. Fisher, a veterinary surgeon, was taken in 1904. The home was located on the corner of Fifth and Ellsworth Avenues. Dr. Fisher's office was located at the rear of the property.

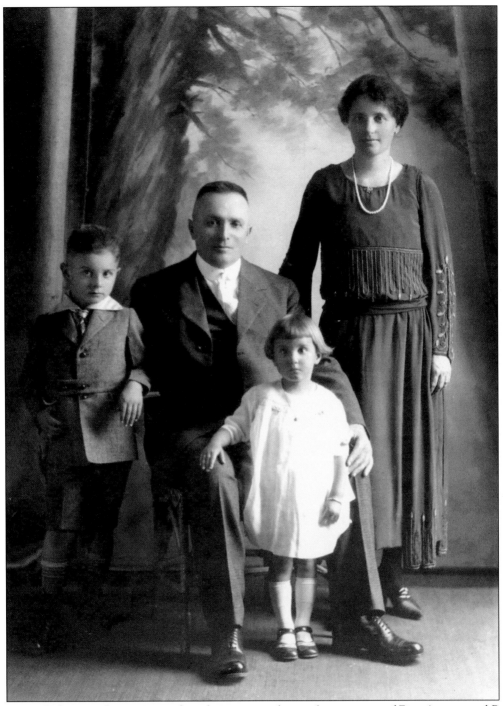

Marco Daba owned a grocery and produce store at the northeast corner of First Avenue and B Street. The Dabas lived on El Dorado Street at the time this family photo was taken c. 1923, but moved to Hayward Avenue shortly afterward. Marco's son Raymond went to local schools, including the College of San Mateo, then went on to graduate from Stanford University and became a prominent attorney.

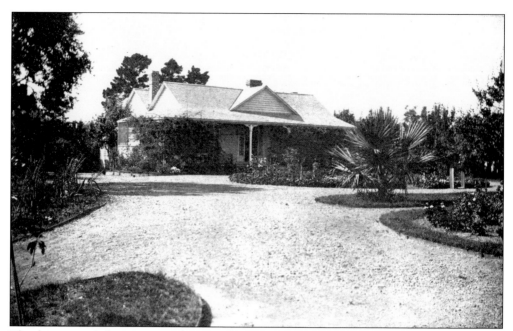

The location of this cottage, photographed in 1904 and belonging to Judge J.P. Brown, is unknown.

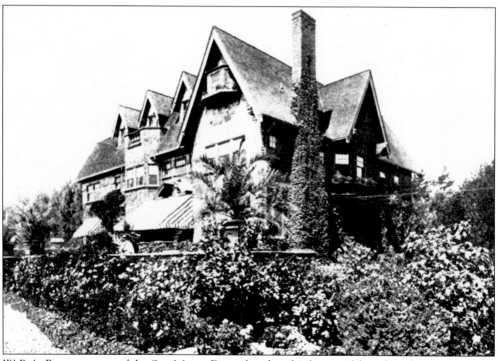

W.P.A. Breuer, owner of the San Mateo Dairy, lived in this house, although its location and the date of the photograph are unknown.

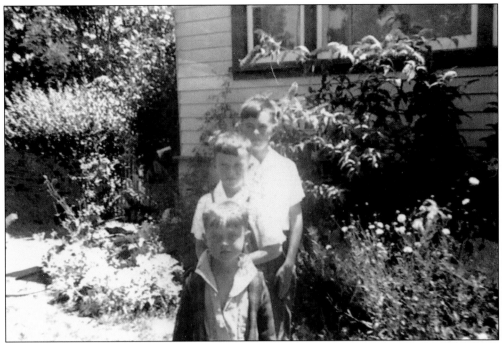

Pictured in the front yard of the Ryan home in 1938 are the Ryan boys, from front to back: Donald, Richard, and James. Richard eventually joined the San Mateo Police Department and retired with the rank of captain.

The George Ryan residence, shown here in 1938, was located at 101 West Twenty-fourth Avenue. The eucalyptus tree at the rear of the home is now in the Twenty-fifth Avenue business district. To the left of the home were open fields and a creek, an idyllic spot for the young Ryan boys to play. Flores Street did not yet exist. The Ryan home has been razed and replaced with an apartment building.

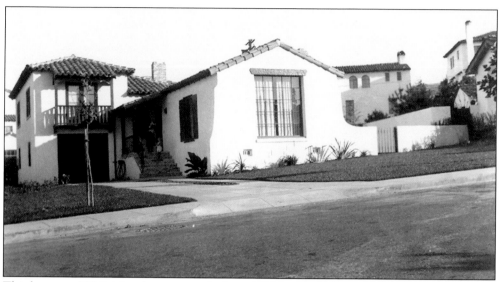

This home at 415 Fairfax Avenue was built in 1933 by Mr. and Mrs. J.M. Chalmers at a cost of $7,500 and would remain their home for the rest of their lives. Built in the popular Spanish Revival style of the time, the house featured custom ironwork, oversized rooms, and three bedrooms elevated over the one-car garage. Mr. Chalmers, an avid gardener, planted a variety of fruit trees, among other plantings, on the property. One of his creations was his "fruit salad tree," which featured grafts of seven fruits on a single tree.

J.M. Chalmers kept scrupulous records of the costs of his new home, as evidenced by this 1933 cost sheet. Because it was built during the worst year of the Depression, cost overruns were to be avoided, and Mr. Chalmers kept a sharp eye on all aspects of the construction.

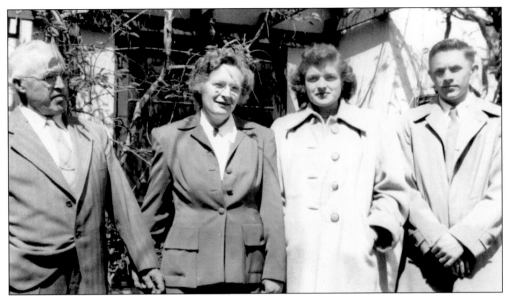

J.M Chalmers, who went by his middle name of Morse, was a third-generation San Franciscan who came to San Mateo after the 1906 earthquake and fire and married Anna Hahn, a fourth-grade teacher at Lawrence School, in 1929. They are pictured here with their children, Helen and Jack, around 1947.

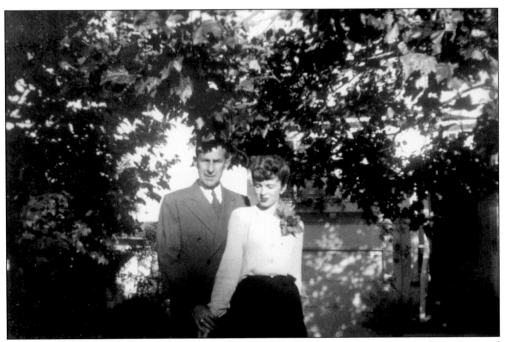

Emmett and Dorothy Funke are pictured in front of their home on Sonora Drive around 1946. The Funkes built the house in 1941 and moved in immediately after they were married. Mr. Funke owned a tire and brake shop at Peninsula Avenue and San Mateo Drive until his retirement in 1968. Their home is possibly the longest continually lived-in residence by an original owner in Aragon.

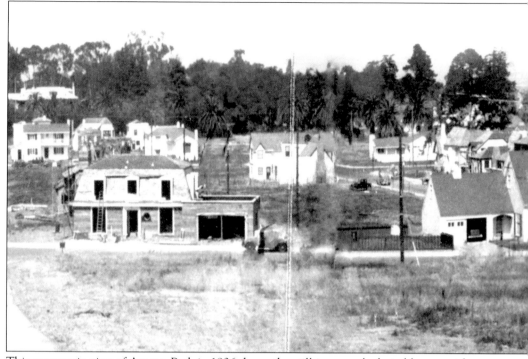

This panoramic view of Aragon Park in 1936 shows the still immensely desirable area with some

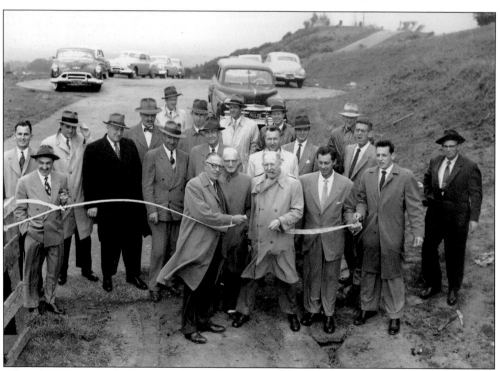

After the popularity of Baywood Park, which opened in the 1930s, the area west of its border, Park Boulevard (now the Alameda de las Pulgas), was opened for development in 1952.

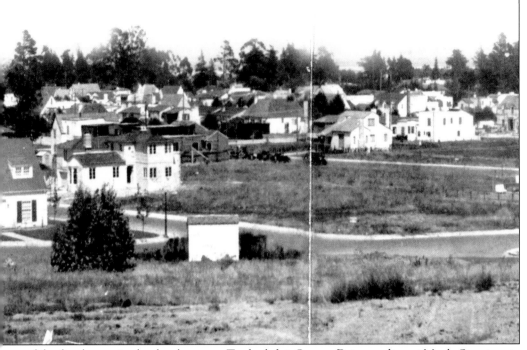

of the first homes in the development. To the left is Sonora Drive, ending at Maple Street.

Kamechiyo Morishita Takahasi, shown here with her husband Genji Takahahsi in 1939, was a midwife for the Japanese community, delivering over 350 babies. She was also the first Japanese woman in the county to obtain a driver's license. Eventually she ran a maternity hospital, charging $20 per delivery and $1 per day for the room before retiring in 1930. The entire Takahashi family was interned at Central Utah Relocation Center, which was also known as "Topaz" during World War II, along with over 700 other San Mateo citizens of Japanese ancestry. Unfortunately, Genji Takahashi died there. Kamechiyo Takahashi lived to be 105, long enough to receive a formal apology from the United States government in 1990 for the internment .

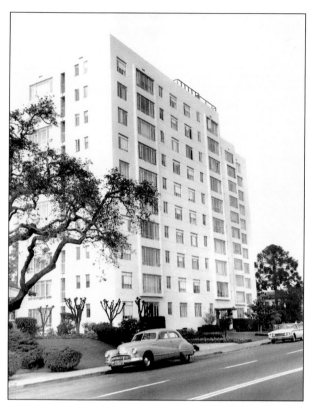

One of the first high-rise apartment houses in San Mateo, the 120 West Third Avenue Apartments adjoin the site where the de Anza party, who discovered and named San Mateo, camped along the creek in 1776.

This "new home for Christmas" advertisement features three distinct new developments in San Mateo in the late 1970s. Bay Ridge Heights (left) shows condominiums high up above Hillsdale. The top right photo shows the award-winning "The Gardens" built at the intersection of Highway 92 and the Alameda de las Pulgas. The Gardens was an unusual design, somewhat loosely based on the Habitat homes from the 1967 Montreal Exhibition where one unit's roof might be another upper unit's deck. It also featured secluded courtyards for some units. San Mateo Marina Homes (bottom, right), claims to offer the last single-family homes in the Bay Area with private boat docks, and included up to four bedrooms with prices starting at $126,000.

Six

SCHOOLS, CHURCHES, AND HOSPITALS

Across the street on the northwest corner of Third and Ellsworth Avenues, St. Matthew's Catholic Church, pictured here in 1900, was built on property was donated by Abby Parrott. The parish was unable to raise the money needed for a new church to replace the small, former one, having managed to collect only $6,000, so Mrs. Parrott generously donated $50,000. Although the church was damaged in the 1906 earthquake, it was repaired and continued in service to the community until another church was built on the grounds of St. Matthew's Parochial School in 1966. Because of Mrs. Parrott's conditions on the deed to the property that it only be used for a church, a legal battle ensued to keep the church, but it was torn down in 1982. The land remained vacant for well over a decade until an agreement could be reached.

The San Mateo High School class of 1911 consisted of 11 students, outnumbering the faculty by only one person. Pictured, from left to right, are seniors (bottom row) Brayton C. Hahn and Williman F. Kilcline; (center) Stephen M. Jarrett; (top row) Hazel M. White and Dorothy T. Chalmers.

The balance of the San Mateo High School class of 1911 graduates, from left to right, are (bottom row) Josephine L. Gardner and Ruth H. O'Brien; (center) Eleanor H. Gettings; (top row) Hazel M. Turner and Ina J. Knapp.

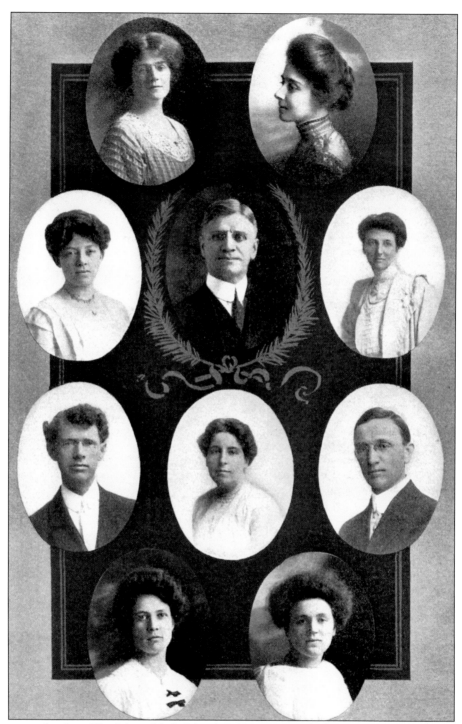

The entire faculty of San Mateo High School in 1911 consisted of ten teachers for 173 students. Pictured, from left to right, are (bottom row) Jennie A. Commings and Stella M. Carlyle; (second row) Robert N. Faulkner, Marie Borough, and George G. Kahl; (third row) Clara B. Berg, O.A. Johnson, and Marietta E. Diggles; (top row) Beatrice M. Murray and Gertrude Cook.

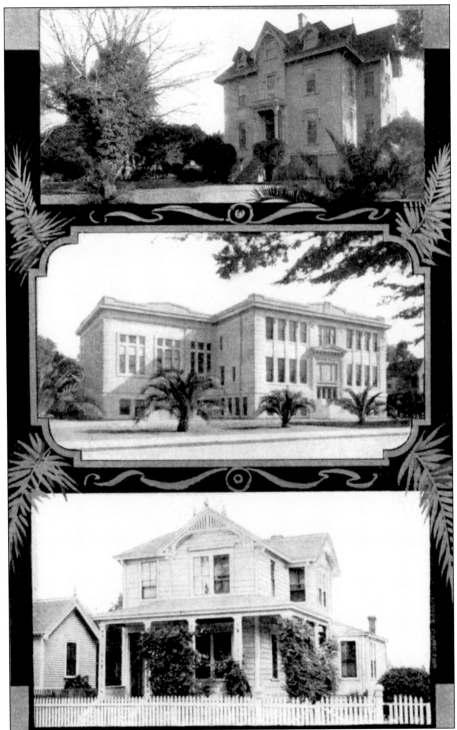

San Mateo High School had three campuses, with the lower picture showing the first high school building from 1902 to 1903. The middle picture is of the campus from 1911 to 1927, and the upper picture shows the campus from 1903 to 1911.

SAN MATEO UNION HIGH SCHOOL

C+

SUBJECT *English 3*

Name *Joseph Coll* Date *Sept. 13 1905.*

High-School Life

High-School Life is a mixture of pleasure and hard work. By High-School life I mean the time between the Grammar school and the time of entering College. In High-School a pupil must study hard. During study periods he must work, and in the evenings at home must prepare his lessons for the following day. Yes, High-School life is a mixture of pleasure and hard work. By the pleasure we have in High School. I mean the amusements we have in Baseball, Tennis, and other games.

Written in wide penmanship, young Joe Coll pads his 1905 essay with explanations about high school life, even describing high school as "the time between grammar school and college." Obviously he was required to write a certain number of words for this essay.

You are cordially invited to attend the

exercises to be held at the

San Mateo Union High School

on the occasion of the

Laying of the Corner-stone

and the formal opening of the

New High School Building

Friday, May 5th, 1911

at 2 o'clock

❖ ❖ ❖

J. C. ROBB, PRESIDENT

C. N. KIRKBRIDE, CLERK

M. A. CALLAGHAN

C. K. MELROSE

N. D. MORRISON

HIGH SCHOOL BOARD

O. A. JOHNSON, PRINCIPAL

On Friday, May 5, 1911, the town was invited to gather at 2 p.m. for the official "Laying of the Cornerstone" and the formal opening of the new San Mateo High School at the corner of Baldwin Avenue and San Mateo Drive (then known as Griffith Avenue). The Peninsula Band played for a half-hour in the auditorium until Mr. O.A. Johnson made the introductory remarks. The dedicatory address was made by David Starr Jordan, Ph.D. Later, at 3:45 p.m., the outdoor exercises began, with the Peninsula Band playing once again and the cornerstone being laid by Mr. J.C. Robb after an address by Mr. Franklin Swart. The Peninsula Band closed out the program with more music and the building was opened to visitors. Members of the reception committee staffed the various rooms. The new school, built of reinforced concrete, was situated on 5 acres, had 25 classrooms and laboratories, and a seating capacity in the auditorium for 500. Havens and Toepke were the architects; Lang and Bergstrom were the contractors. The cost was $100,000, not including equipment. When San Mateo High School built yet another, larger campus on Delaware and Poplar Streets in 1927, this building became the San Mateo Junior College. It was razed in the 1980s and is now the site of the Medical Arts Building.

In 1914, for the second time, San Mateo High School's basketball team won the All American League championship, winning every game that year, even their practice games, and sometimes beating their opponents by as much as 46 points. Team members shown, from left to right, are (front row) Sheldon Perham (team captain) and Fred "Duck" Teal; (back row Harold Barneson, Edgar Batchelder, and Alvin Chalmers.

None of the players are identified in this 1914 San Mateo High School baseball team photo. San Mateo won 11 games and lost 6 that season, scoring 109 runs to their opponents' 84, including 2 tied games.

The 1914 San Mateo High School girls' basketball team did not fare as well as the boys' team that season, only winning one-third of the games in which they played. The lineup includes, from bottom to top, Rose Halloran (team captain), Edythe Kyle, Ella Royden, Ruth Krug, Nora Gittings, and Helen Cooke.

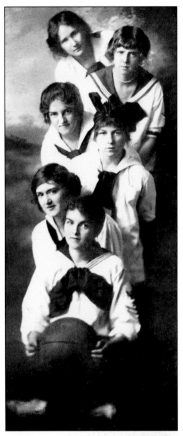

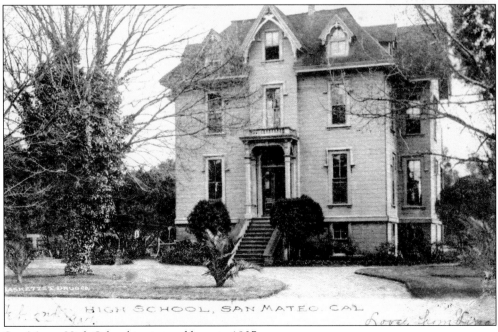

San Mateo High School is pictured here in 1907.

Definitely reflecting the Arts and Crafts style of the times, the cover of the 1914 yearbook for San Mateo High School, *The Elm*, is a work of art in itself.

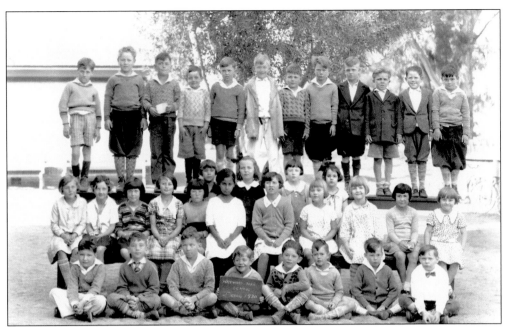

The second-grade class of Hayward Park School poses for its 1930 school photo.

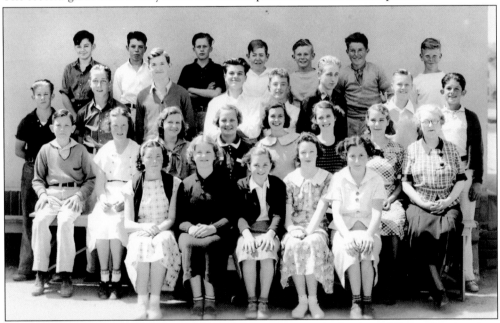

In 1937 the same Hayward Park School class is ready to go to high school. The graduating class, from left to right, included (first row) Beverly Lowns, Margaret Wylie, Dorothy Kerscher, Muriel Coll, and Rena Revetria; (second row) Ike Larsen, Albert Manson, Myron Kimnach, Stanley Miller, Charles Manuel, Bob Schwerin, Billy Huber, and Leslie Foppiano; (third row) Herbert Martin, Betty Garbini, Barbara Benoit, June Drinkwater, Dorothy Pires, Jeanne Wallace, and Catherine Zovera; (fourth row) Kay Therp, Frank Vaillancourt, Paul Van Boven, Dob Drisko, Bob Dalton, Jerry Sheehan, and Peter Agur. The class motto was "Learning is an ornament in prosperity, a refuge in adversity, and a provision in old age."

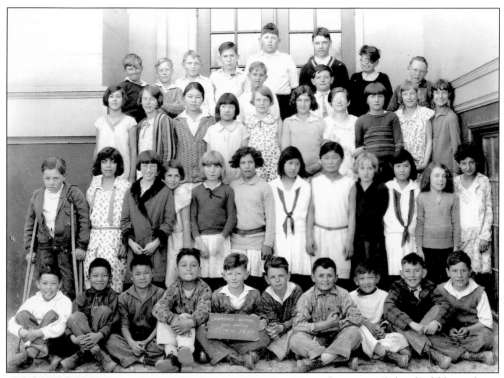

Lawrence School's fifth-grade class poses for this 1930 photo.

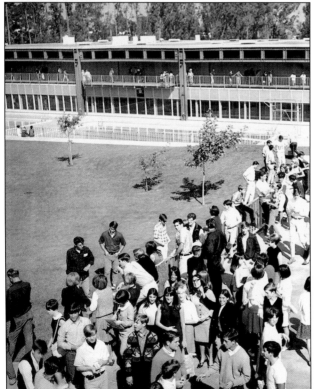

Built in 1961, Aragon High School sits on what was originally part of the Tobin Clark estate. It was rumored that it could be quickly converted to a munitions factory in case of war. Among Aragon's features were numerous interior courtyards, such as the one shown here in 1966, and interior walls that could be moved. It was not uncommon to return for a new school year and find the classrooms in a totally different configuration.

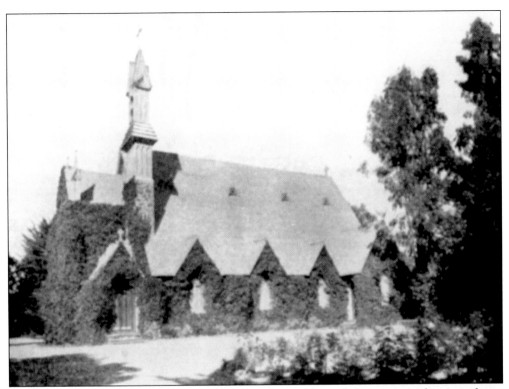

In 1904 the Episcopal Church of St. Matthew was a beautiful ivy-clad structure with a magnificent bell tower and a fine stained-glass window. The April 18, 1906 earthquake caused the bell tower to collapse, making the building unusable. However, the quake didn't destroy the stained-glass window or the spirit of the church members as plans to rebuild commenced very soon in 1906. Today's St. Matthew's Episcopal is even more beautiful than the original and stands at the same location on El Camino Real between Second and Baldwin Avenues.

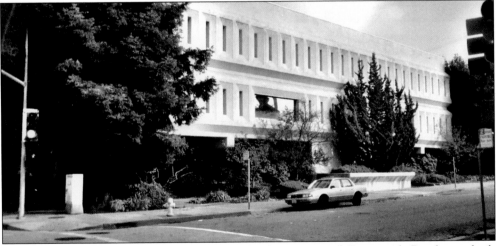

The San Mateo Public Library, located at Third Avenue and Dartmouth Road, was built in 1969 to replace the structure on Second Avenue and San Mateo Drive (now the Mills–Peninsula Health Center parking lot). This structure was torn down in 2003 and will be replaced on the same site with a new, larger library by 2007.

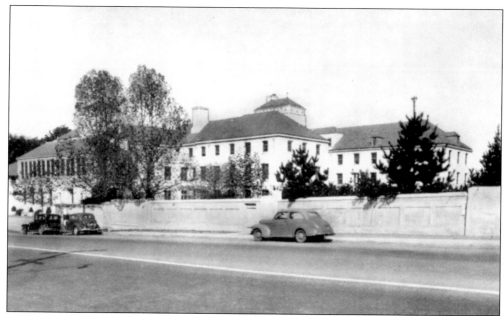

Mills Hospital, as seen from El Camino Real in 1937, was founded by Elizabeth Mills in 1908. It has expanded numerous times and today is called the Mills–Peninsula Health Center. All inpatient hospitalizations now take place exclusively at Peninsula Hospital in Burlingame, while the Mills site offers outpatient and emergency services.

This Mills Hospital addition was constructed in 1961. Another structure was added a couple of decades later, obscuring this part of the hospital from view.

These people attended a first aid class given at San Mateo Junior College in 1949.

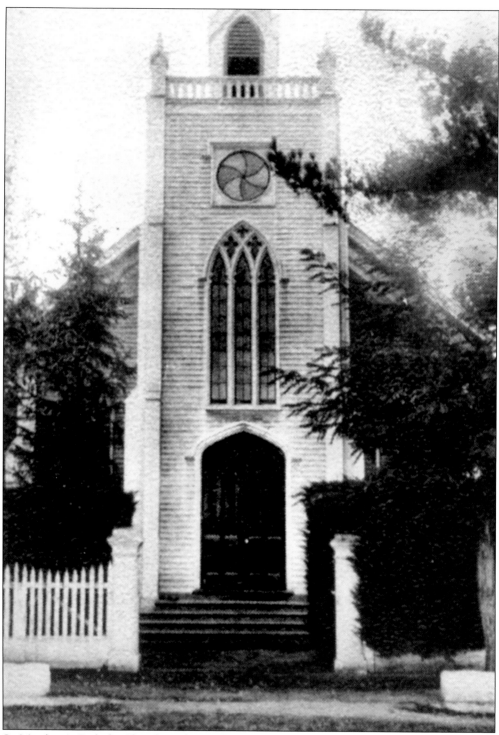

St. Matthew's Catholic Church on the southwest corner of Third and Ellsworth was built in 1884 on land donated by Mr. C.B. Polhemus. It was dedicated on February 7, 1864 by Archbishop Joseph Sadoc Alemany of San Francisco.

Seven

VIEWS AND EVENTS

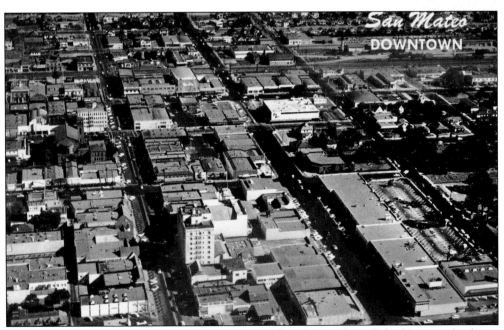

This aerial view shows downtown San Mateo in the 1960s. The tall building in the lower foreground is the Benjamin Franklin Hotel on Third Avenue, named after one of its developers not the renowned statesman.

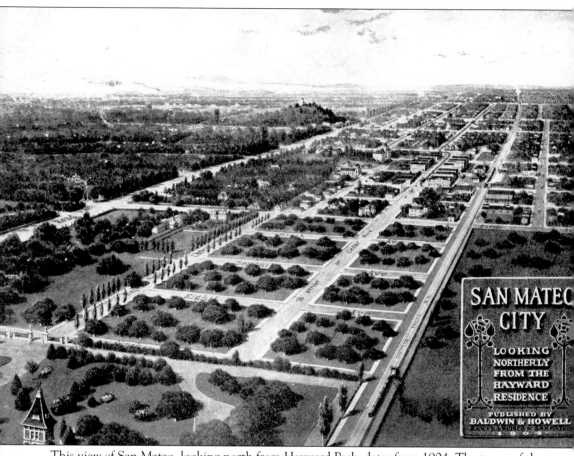

This view of San Mateo, looking north from Hayward Park, dates from 1904. The tower of the Alvinia Hayward estate (later the Peninsula Hotel) can be seen in the lower left corner.

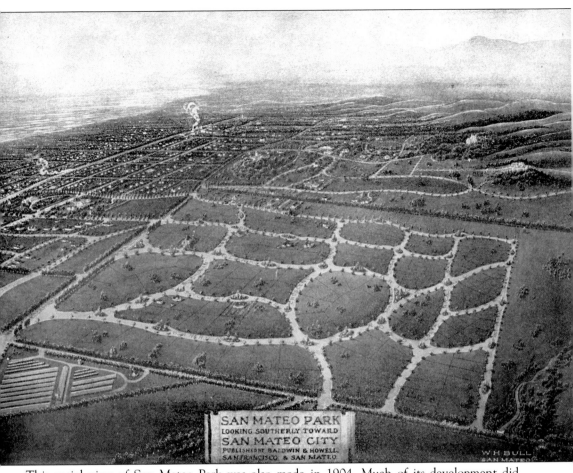

SAN MATEO PARK
LOOKING SOUTHERLY TOWARD
SAN MATEO CITY
PUBLISHED BY BALDWIN & HOWELL.
SAN FRANCISCO & SAN MATEO.

W.H.BULL
SAN MATEO

This aerial view of San Mateo Park was also made in 1904. Much of its development did not occur until the 1910s and after. It remains one of San Mateo's choicest and most desirable neighborhoods.

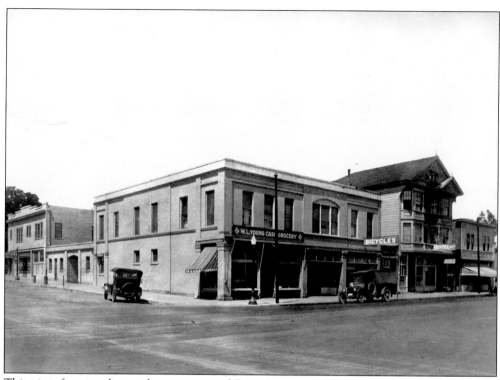

This view features the northwest corner of First Avenue and B Street, around 1910. On the corner is W.L. Young Cash Grocery and an unnamed bicycle shop mid-block.

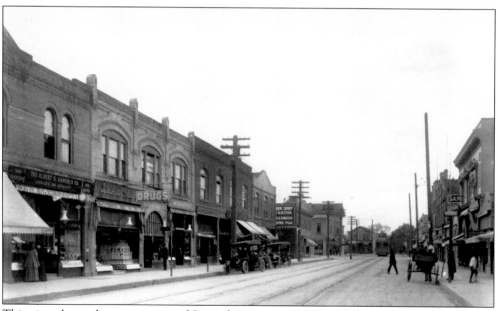

This view shows the intersection of Second Avenue and B Street, date unknown. On the left side of the street is the Albert S. Samuels Jewelry Company, the Baskette Drug Store, and Levy Bros.

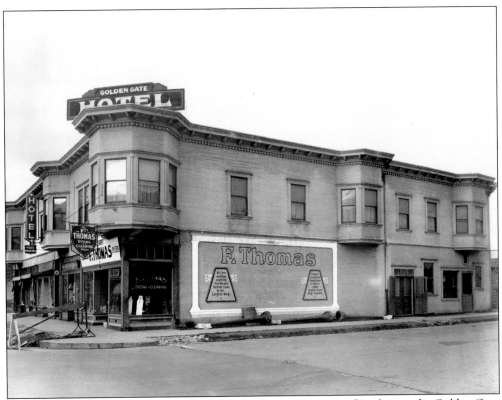

This view shows the corner of First Avenue and B Street. The upper floor houses the Golden Gate Hotel, while on the ground level is the F. Thomas Dye and Cleaning Works on the corner.

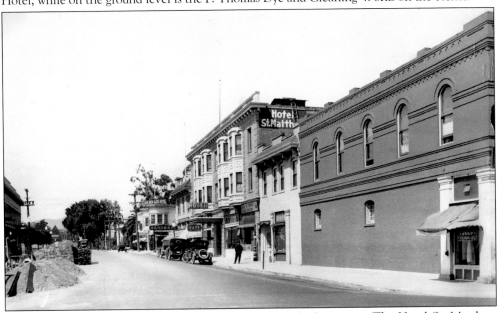

This undated view is of Second Avenue and B Street, looking west. The Hotel St. Matthew exists to this day. Ground floor businesses include Wisnom's Hardware, a cafe, an optician, and a barbershop.

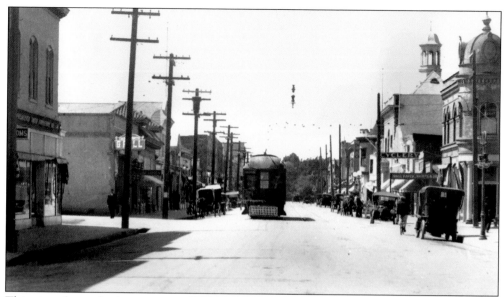

This view shows the intersection of Third Avenue and B Street. The building at the far right corner of the picture still stands, although somewhat altered in appearance. On the left side, behind the first telephone pole, is the sign for the "Irish Grotto Grill."

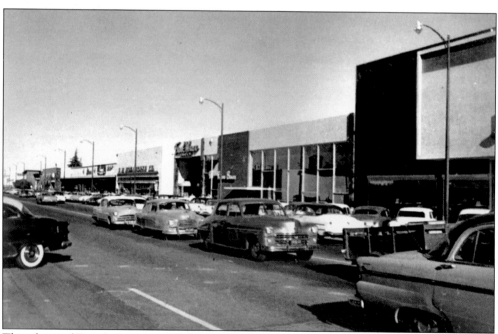

This photo of Fourth Avenue at El Camino Real, looking east, was taken in the 1950s. Among the stores that can be seen are, from left to right, F.W. Woolworth & Co., Frank Meyer Shoes, Roos Bros. (later Roos-Atkins), and J.C. Penney (large building on the right). None of the stores occupy those locations any longer, and all but Penney's have gone out of business.

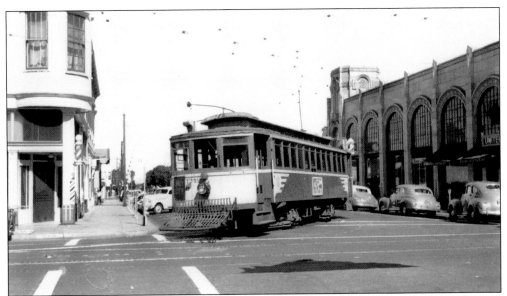

San Mateo's Second Avenue and B Street are shown here in 1946. The Art Deco Merkel Building, seen on the right, still stands.

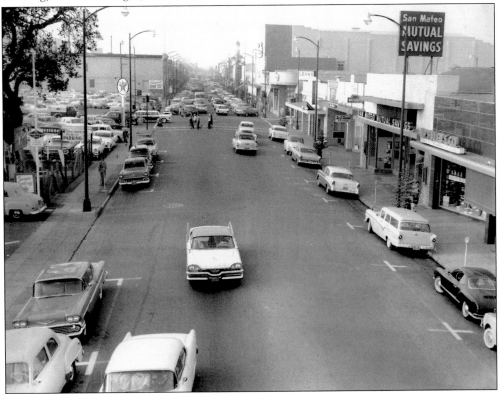

This photo shows another view of B Street, this time between Fourth and Fifth Avenues looking north, taken around 1959. The large blocky building in the background was the Baywood Theatre, which later became Thrifty's Drugstore. San Mateo Mutual Savings & Loan, which later became Bell Savings and Fuller Paints, is on the right side of the street.

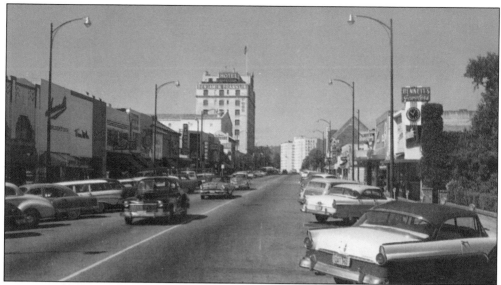

This view of Third Avenue at Ellsworth Avenue looks west sometime in the 1950s. The Benjamin Franklin Hotel is the tall building on the left. The clock on the right is part of Bennett's Jewelers sign.

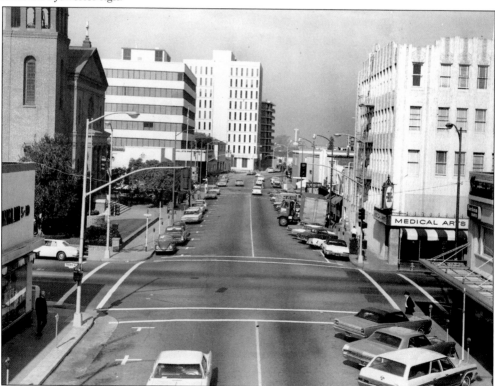

This photo from the bridge of the parking structure, looking north up Ellsworth Avenue at Third Avenue, was taken in 1968. To the left is old St. Matthew's Catholic Church. The five-story building on the right is the Art Deco Medical Arts Building. It housed a pharmacy on the ground floor and doctors' offices above. The building is still there.

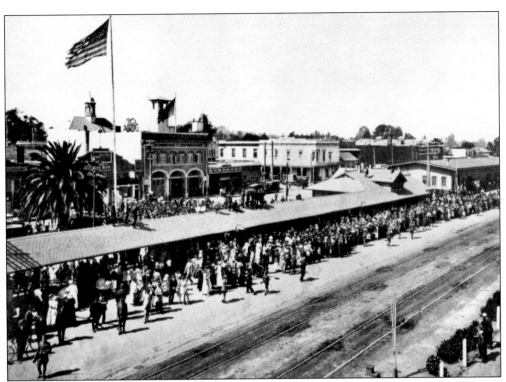

President McKinley visited San Mateo in 1901. In this view, most of the citizens of San Mateo await his arrival at the train depot on Main Street.

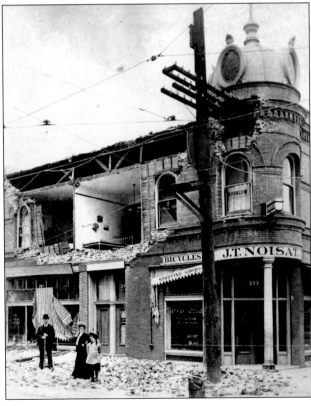

This photo shows the 1906 earthquake damage to photographer P.L. Noisat's shop in the Coleman Building.

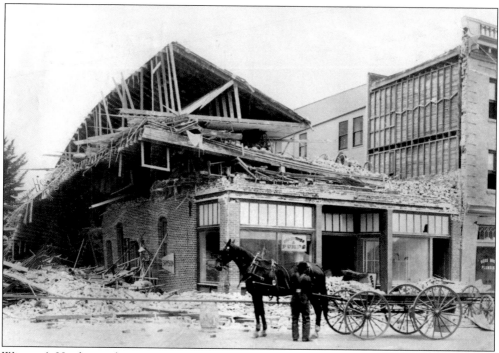

Wisnom's Hardware also sustained damage in the 1906 quake.

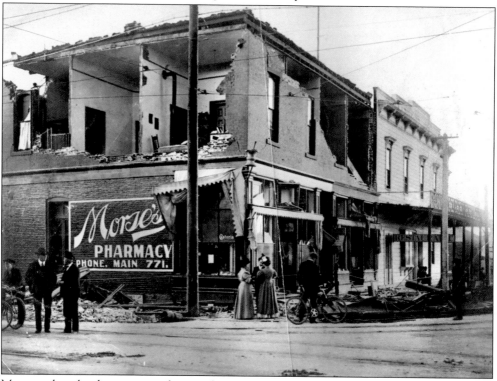

More earthquake damage is evident at the corner of Second Avenue and B Street, where an upper wall above Morse's Pharmacy has collapsed, completely exposing the rooms.

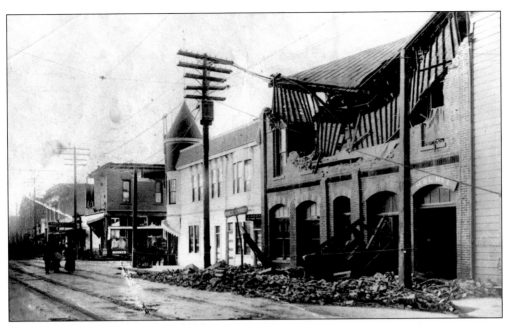

This view of B Street dates from 1906.

The April 18, 1906 earthquake also damaged St. Matthew's Catholic Church. The church was repaired and used daily until a new church was built on the grounds of St. Matthew's School on El Camino at Ninth Avenue in 1966. In 1982, this structure was deemed seismically unsafe and torn down, even though it had withstood the 1906 earthquake. San Mateo's downtown area had lost one of its most stately structures. It was replaced with a Walgreens Pharmacy after two decades of legal complications begun by disgruntled parishioners.

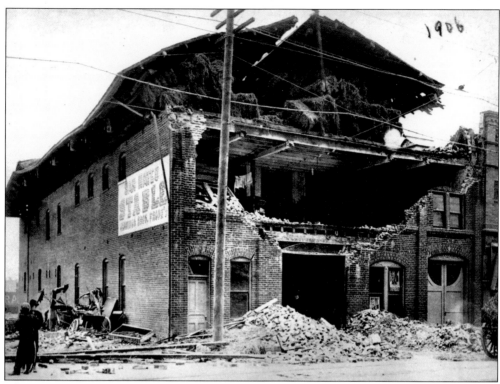

The 1906 earthquake damage to the San Mateo Stables was extensive. The building was repaired and now houses Gymboree.

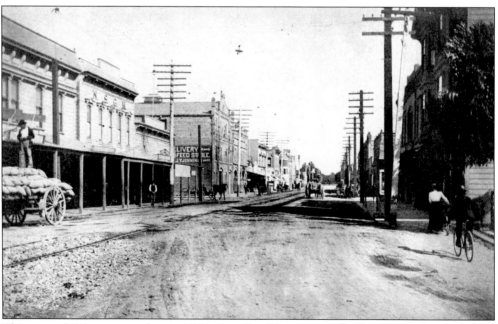

This view of B Street was taken in 1904 when San Mateo was still a "small town" and life here was simple, honest, and taken at a very slow pace.